GOLTZIUS *and the* THIRD DIMENSION

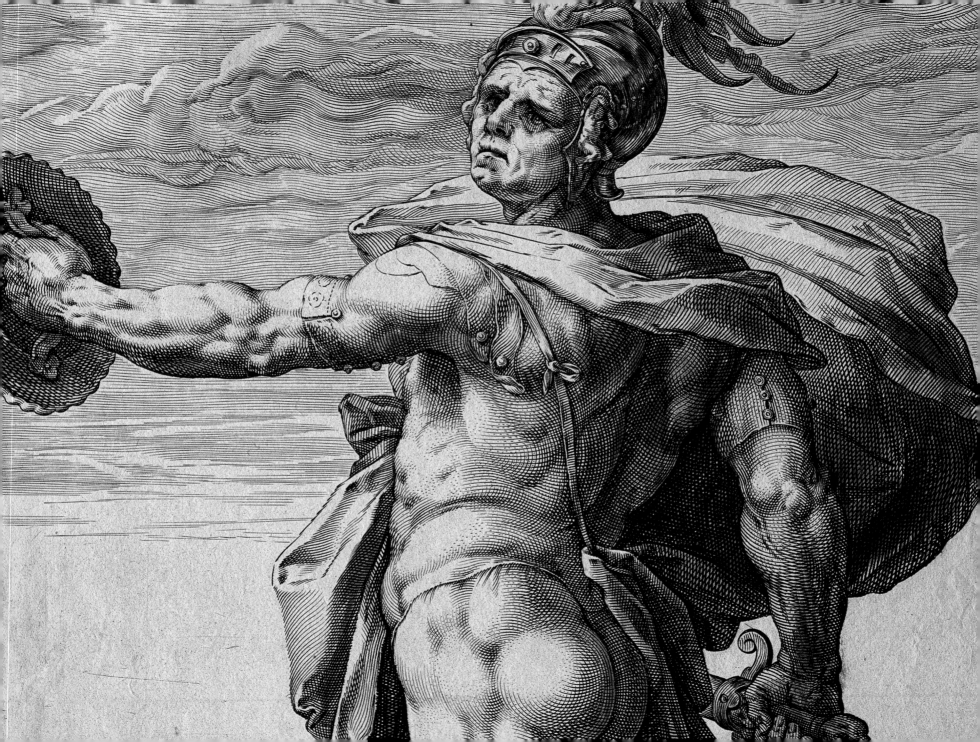

GOLTZIUS

& THE THIRD

DIMENSION

STEPHEN H. GODDARD

JAMES A. GANZ

STERLING AND FRANCINE CLARK ART INSTITUTE

WILLIAMSTOWN, MASSACHUSETTS

Published on the occasion of the exhibition
Goltzius and the Third Dimension

Sterling and Francine Clark Art Institute
Williamstown, Massachusetts
October 7, 2001–January 6, 2002

Elvehjem Museum of Art
University of Wisconsin
Madison, Wisconsin
January 19–March 16, 2002

Spencer Museum of Art
The University of Kansas
Lawrence, Kansas
March 30–May 19, 2002

This exhibition has been organized by the Sterling and
Francine Clark Art Institute, Williamstown, Massachusetts.

Cover illustrations: *(front)* Details of Tetrode's *Nude/Warrior Deity*
(fig. 10) in reverse and Goltzius's *Publius Horatius* (fig. 22); *(back)*
Goltzius's *Pluto* (fig. 55)

Frontispiece: Detail of Goltzius's *Calphurnius* (fig. 12)

Designed by Diane Gottardi

Color separations and printing by Thames Printing Company,
Norwich, Connecticut

Sterling and Francine Clark Art Institute
225 South Street
Williamstown, MA 01267
www.clarkart.edu

Printed and bound in the United States of America
10 9 8 7 6 5 4 3 2 1

Principal photography by Michael Agee with the assistance of Merry Armata, © Sterling and Francine
Clark Art Institute. Additional photography credits are as follows:

© The British Museum, London (fig. 19); © Kupferstichkabinett, Staatliche Museen zu Berlin-Preussischer
Kulturbesitz, photo Jörg P. Anders (fig. 21); Musée des Beaux-Arts et d'Archéologie, Besançon, photo
Charles Choffet (fig. 8); Private collection, United States (fig. 18); Réunion des Musées Nationaux, Paris,
photo Ojéda/Hubert (fig. 39); © Rijksmuseum-Stichting, Amsterdam (fig. 3); Soprintendenza per i beni
Artistici e Storici Gabinetto Fotografico, Florence (figs. 1, 2, 15); Spencer Museum of Art, The University
of Kansas, Lawrence (figs. 31–33); © Teylers Museum, Haarlem (figs. 37, 38)

Library of Congress Cataloging-in-Publication Data

Goddard, Stephen H.
 Goltzius and the third dimension / Stephen H. Goddard, James A. Ganz.
 p. cm.
 Published on the occasion of the exhibition held at Sterling and Francine Clark Art Institute,
Williamstown, Mass., Oct. 7, 2001–Jan. 6, 2002, at Elvehjem Museum of Art, University of
Wisconsin, Madison, Wis., Jan. 19–March 16, 2002, and at Spencer Museum of Art, University
of Kansas, Lawrence, Kan., March 30–May 19, 2002.
 ISBN 0-931102-43-X (pbk. : alk. paper)
 1. Goltzius, Hendrick, 1558–1617—Exhibitions. 2. Tetrode, Willem Danielsz van,
ca. 1525–1580—Influence—Exhibitions. 3. Male nude in art—Exhibitions. 4. Prints—Private
collections—United States—Exhibitions. 5. Hearn Family Trust—Art collections—Exhibitions.
I. Ganz, James A. II. Sterling and Francine Clark Art Institute. III. Elvehjem Museum of Art.
IV. Helen Foresman Spencer Museum of Art. V. Title.

NE670.G65 A4 2001
769.92–dc21

2001047098

Contents

This exhibition is the result of an important collaboration between two curators—James Ganz of the Sterling and Francine Clark Art Institute and Stephen Goddard of the Spencer Museum of Art at the University of Kansas. As both an art museum and research center, the Clark is especially well positioned to organize such an exhibition, one that both displays some of the most dazzling examples of Dutch Mannerist prints and sculptures as it also explores an important and vexing issue in late-sixteenth-century scholarship. It is a question first posed about thirty years ago, one that concerns the possible relationship between the bronze statuettes of Willem Danielsz. van Tetrode and the engravings of Hendrick Goltzius. The great appeal of this subject derives, in large part, from the powerful virtuosity of the works of art at the core of the argument. This is the first opportunity for the general public and scholarly community to

Detail of Goltzius's
Mars in Half-Length (fig. 47)

examine the evidence and judge for themselves how close the relationship is between the works of these great Mannerist artists.

We want to thank the Hearn Family Trust for allowing us to examine this issue through the generous loan of three bronzes attributed to Tetrode and thirty-three related prints by Goltzius and his circle. We appreciate their discrimination, enthusiasm, and cooperation in every way in making this project a reality. I also want to take the opportunity to express my gratitude to Michael Agee and Merry Armata of the Clark's photography department. The stunning images throughout this catalogue testify to their dedication and skill.

Michael Conforti
Director, Sterling and Francine Clark Art Institute

ACKNOWLEDGMENTS

The authors are deeply indebted to Charles Hack and Angela Hearn and the officers of the Hearn Family Trust for the opportunity to study and exhibit the Trust's extraordinary collection. We benefited especially from Charles's passion for this subject, which is reflected in the unique collection of Goltzius prints and Tetrode bronzes he has assembled.

At the Clark Art Institute, numerous staff members have contributed to the success of this exhibition and catalogue. In particular we wish to thank Michael Agee, Brian Allen, Merry Armata, Harry Blake, Jennifer Cabral, Michael Cassin, Michael Conforti, Paul Dion, Lisa Dorin, David Edge, Lindsay Garratt, Sherrill Ingalls, Mattie Kelley, John Ladd, Jordan Love, Paul Martineau, Saul Morse, Katie Pasco, Kate Philbin, Richard Rand, Curtis Scott, Robert Slifkin, Nancy Spiegel, and Noel Wicke. In addition, we would like to acknowledge the efforts of June Cuffner, Diane Gottardi, Scott Hayward, and Alison Rooney.

At the Spencer Museum of Art, we thank Robert Hickerson, Andrea Norris, and Cori Sherman; at the Elvehjem Museum of Art, Russell Panczenko and Andrew Stevens.

We appreciate the willingness of the Bowdoin College Museum of Art to lend one of Goltzius's *Four Disgracers,* which allowed us to exhibit and study this group of prints in its entirety. At Bowdoin, our thanks go to Katy Kline, Laura Latman, and José Ribas.

A number of individuals have shared their expertise with us and have provided assistance in gathering photographs and bibliography: we thank Carmen Bambach, Holm Bevers, James Draper, Daniel Katz, Jan Piet Filedt Kok, Huigen Leeflang, Thomas Martone, Lawrence Nichols, Nadine Orenstein, Anthony Radcliffe, Alan Rosenbaum, Martin Royalton Kisch, Frits Scholten, and Richard Stone.

GOLTZIUS *and the* THIRD DIMENSION

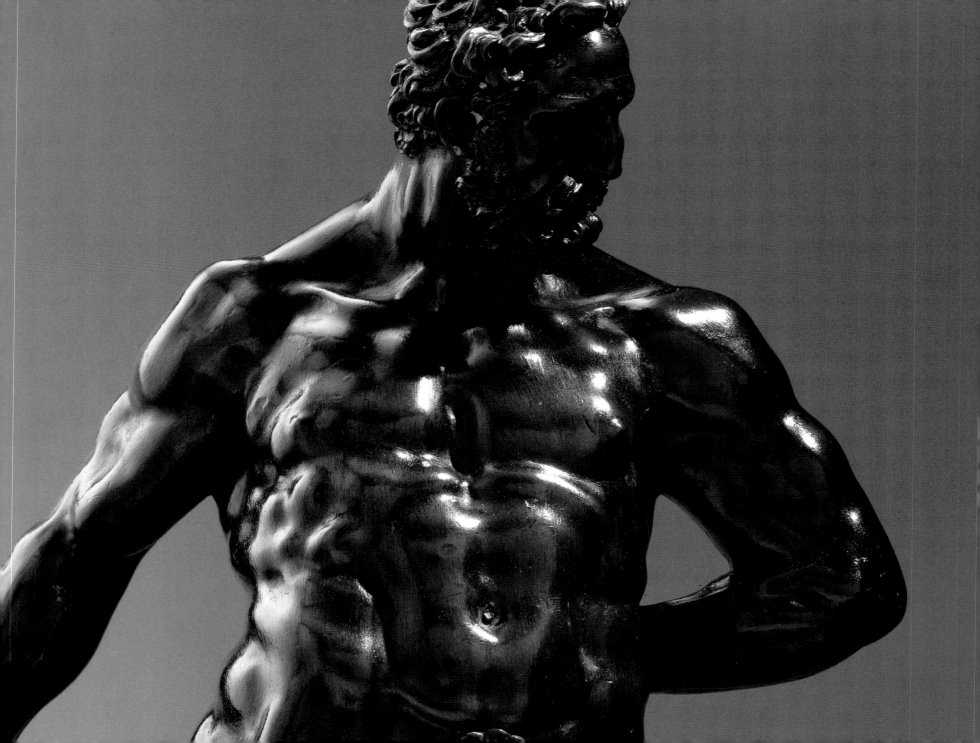

GOLTZIUS WORKING *around* TETRODE

STEPHEN H. GODDARD

The great German Renaissance artist Albrecht Dürer (1471–1528) brought woodcut and engraving to remarkable levels of perfection, defining the technical and aesthetic potential of print mediums for years to come. This achievement has been universally recognized in Dürer's woodcut series *The Apocalypse* of 1498 and his three "master engravings" *(Knight, Death and the Devil, Saint Jerome in His Study,* and *Melencolia I)* of 1513–14. Dürer refined the woodcut to the point that it could emulate the fluidity of pen drawing; with the engraver's burin, he developed systems of swelling and tapering lines that could convey the tactile sense of myriad forms and textures.

The sixteenth century was one of the most fertile periods in the history of printmaking, and yet throughout this century Dürer's achievement remained an almost unattainable precedent. At the end of the sixteenth century, however, Hendrick Goltzius (1558–1617), an artist from the Lower Rhine whose career was ultimately centered in Haarlem, rivaled Dürer's achieve-

Detail of Tetrode's
Hercules Pomarius (fig. 4)

ment, consciously assimilating the earlier master's example and expanding the horizon of virtuosity with a new array of skills. Goltzius not only mastered woodcut and engraving as they were understood in Dürer's day, he perfected the technique of chiaroscuro woodcut that Dürer's contemporaries had explored, and he articulated a system of linear engraving that was even more spellbinding than that elaborated by the German Renaissance master. Goltzius also pioneered calligraphic engraving in the Netherlands and in his "pen works" he developed a new graphic medium.[1] The latter were drawings in the manner of engravings and often monumental in scale, as if to blur the distinction between the graphic arts and painting.[2]

Goltzius's graphic output is infused with a profound understanding of art history from antiquity to his own day. For example, each of the six sheets of his best-known series of engravings, *The Life of the Virgin,* evokes the art of German, Dutch, or Italian masters (both contemporary and historical figures, Dürer among them). The exhibition *Goltzius and the Third Dimension* tests the hypothesis, articulated in 1984 by Anthony Radcliffe, that for a period in the 1580s, Goltzius's woodcuts and engravings betrayed a response to the elegant bronze statuettes by Willem Danielsz. van Tetrode (c. 1525–1580).[3] The exhibition not only serves to identify Goltzius's sources, but also is testimony to his insatiable interest in absorbing the most beautiful examples of artistic achievement and recommunicating them through his own graphic expression. The story of Goltzius and Tetrode reveals the ways in which Goltzius subsumed prior artistic achievements and put them to work in his own remarkable inventions.

THE ARTISTS

Willem Danielsz. van Tetrode has received relatively little attention because so little of his oeuvre has survived.[4] What can be patched together from documents and engraved copies of his work indicates a rather remarkable career. In all probability he was born in Delft around 1525.[5] From 1545 until 1567—or shortly before—he was working in Italy, where he was recorded variously as Guglielmo Fiammingo or Guglielmo Tedesco. His first five years in Italy were spent in the Florentine workshop of the great Mannerist sculptor Benvenuto Cellini (1500–1571), where Tetrode helped to restore an antique torso that emerged from Cellini's workshop as a figure of Ganymede (Museo Nazionale del Bargello, Florence). Tetrode also assisted Cellini on the pedestal of the monumental bronze *Perseus* that was erected in the Piazza della Signoria in Florence between Michelangelo's *David* and Donatello's *Judith and Holofernes*.[6] Cellini is known to have been especially attuned to the notion that sculpture should appear beautiful from multiple vantage points.[7] Tetrode also worked in the Roman workshop of Guglielmo Della Porta (active 1534–1577), whom the Italian artist and art theorist Giorgio Vasari (1511–1574) referred to as Tetrode's teacher. It was Della Porta who restored *The Farnese Hercules,* the third-century Roman copy of Lysippus's *Hercules* that was discovered in 1546 and erected in the courtyard of the Palazzo Farnese in Rome. Tetrode's bronzes betray a clear knowledge of *The Farnese Hercules,* which he must at least have witnessed undergoing restoration in 1547 (the year that he returned to Florence), if indeed he did not participate in it. There appears to be little evidence in

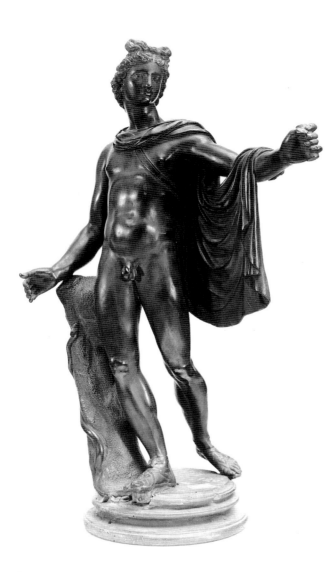

support of the often-repeated theory that Tetrode worked on the *Neptune Fountain* in the Piazza della Signoria with the sculptor Bartolommeo Ammanati (1511–1592).[8] Around 1560 Tetrode produced a series of bronze copies of antique sculptures for the Count of Pitigliano, Gianfrancesco Orsini. Wilhelmina Halsema-Kubes describes these as "12 busts of Roman emperors, an Apollo Belvedere, an Antinous, two copies of the Farnese Hercules (one of them in reverse), an equestrian statue of Marcus Aurelius, a Venus and the Dioscuri" (figs. 1, 2).[9]

Tetrode returned to Delft, possibly bringing models of some of his bronzes with him, shortly after the iconoclastic outbreak of 1566 that was responsible for the destruction of the high altar in the Oude Kerk.[10] Within a year of his return, Tetrode received a commission to replace this high altar and, shortly thereafter, another commission for an altar for the Guild of the Tree of Jesse in the same church. These works were all destroyed in a second wave of iconoclasm in 1573, an event that doubtless contributed to Tetrode's decision to relocate to Cologne, a Catholic city that was friendly to the arts and known for a modicum of religious tolerance.[11] He was not to return to Delft, but his statuettes are documented in private collections there in 1598 and in the early seventeenth century.[12]

Some knowledge of Tetrode's activity in Cologne and its environs can be gleaned from the inscriptions on prints that reproduce his sculptural work. An engraving by Adriaen de Weerdt (c. 1510–c. 1590) after Tetrode's *Mercury and Minerva,* for example, indicates that Tetrode found work as an architect for archbishop and elector Salentin von Isenburg.[13] Another de Weerdt engraving

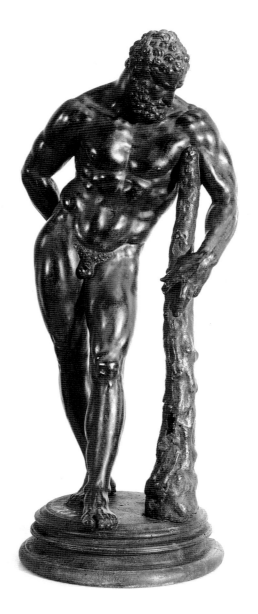

FIG. 1. Willem Danielsz. van Tetrode, *Copy after "The Apollo Belvedere,"* c. 1560. Bronze, height 23 inches (58.5 cm). Museo Nazionale del Bargello, Florence

FIG. 2. Willem Danielsz. van Tetrode, *Copy after "The Farnese Hercules,"* c. 1560. Bronze, height 25 1/4 inches (64 cm). Museo Nazionale del Bargello, Florence

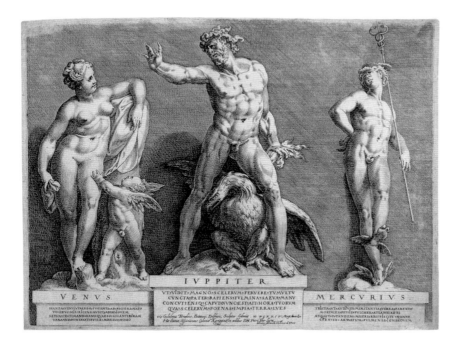

shows that Tetrode's *Venus, Jupiter, and Mercury* (fig. 3) could be found in the house of Peter Therlan von Lennep, a powerful member of the town council in Cologne.[14] It is also possible that Tetrode worked on an elaborate chimneypiece for Salentin von Isenburg's marshal, Rütger von der Horst, at Horst Castle. Anna Jolly has shown that this chimneypiece incorporates elements from Tetrode's *Warrior on Horseback* (J. Paul Getty Museum, Los Angeles) and the *Venus, Jupiter, and Mercury* known through de Weerdt's engraving.[15] Jolly has also established that Tetrode died in 1580, perhaps of the plague, while working on renovations at Arnsberg Castle in Westphalia.[16]

FIG. 3. Adriaen de Weerdt after Willem Danielsz. van Tetrode, *Venus, Jupiter, and Mercury*, 1574. Engraving, 16 1/2 x 21 inches (41.9 x 53.3 cm). Rijksmuseum-Stichting, Amsterdam

8

De Weerdt, whose career strikes some interesting parallels with that of Tetrode, presents the possibility of contact with both Tetrode and Goltzius. Born in Brussels around 1510, he traveled to Italy, apparently in the early 1560s when Tetrode would also have been in Italy. According to the author and artist Karel van Mander (1548–1606), de Weerdt became obsessed with emulating the Mannerist idiom of the Italian painter Parmigianino (1503–1540).[17] He resumed his career in Brussels upon his return, but by 1566 the Lutheran de Weerdt and his mother relocated to the more tolerant Cologne.[18] In Cologne he not only made engravings after Tetrode's sculptures, but worked closely with Dirck Volckertsz. Coornhert (1522–1590), an important engraver and freethinker who became Goltzius's teacher and mentor. Coornhert had been arrested in Haarlem in 1567 and, after escaping in 1568, fled to Cologne to avoid further persecution. While he ultimately left Catholic Cologne in favor of more sympathetic towns nearby, including Xanten, his presence in Cologne was adequate to cement a friendship with de Weerdt.[19] Coornhert engraved a number of prints after de Weerdt's designs, and when Coornhert returned to Haarlem with his young protégé, Hendrick Goltzius, he seems to have taken several de Weerdt drawings with him. Specifically, Ilja Veldman speculates that the so-called "vier sinnekens" (four emblematic prints) after de Weerdt drawings may have been engraved jointly by Goltzius and Coornhert upon their relocation to Haarlem in 1577.[20]

Hendrick Goltzius's early career was centered in the Lower Rhine. Born in Mülbracht and raised in Duisburg, Goltzius began studies with Coornhert in Xanten in about 1574. The Lower Rhine (a loose geographical term desig-

nating areas of modern political Germany, the Netherlands, and Belgium near the Rhine as it descends toward the North Sea) has often been characterized as a region subject to a rich cultural and artistic exchange.[21] This situation, fostered by linguistic affinities and connections forged by the old Hanseatic trade routes, encouraged travel and communication between the Low Countries and the Lower Rhine. Given Coornhert's friendship with de Weerdt and the geographic proximity, it would be surprising if the young Goltzius did not encounter the circles of de Weerdt and Tetrode in Cologne. While there are undoubtedly other means through which Goltzius might have become acquainted with the sculptural work of Tetrode, his early career in the vicinity of Cologne certainly provided one such opportunity.

Goltzius's printmaking career began in earnest with his 1577 move to Haarlem with Coornhert. Shortly after, in 1579, Goltzius married Margaretha Jansdr. His stepson, Jacob Matham (1571–1631), would become an important engraver in the Goltzius circle. In Haarlem Goltzius worked initially for the Antwerp-based print publishing firm of Philips Galle, but by 1582 he began publishing prints on his own. The following year was of critical importance for Goltzius, for it was then that van Mander settled in Haarlem.

Van Mander, originally from the area of Cortrijk in the southern Netherlands, had traveled in Italy and to Vienna prior to his arrival in Haarlem. Van Mander was a Mennonite, and his move to the northern Netherlands was prompted by the need for religious freedom. Van Mander's fame rests primarily upon the highly important text *Het Schilder-boeck,* published in 1604, variously translated as "The Painter's Book" or "The Book on Picturing."

This text incorporates six sections, the best known dealing with the lives of Dutch and German artists. The *Schilder-boeck* also includes an important treatise on painting theory, a treatment of the lives of Italian and ancient artists, a discussion of Ovid's *Metamorphoses,* and an iconographical guide to rendering figures.[22] As Walter Melion has argued, van Mander wrote about Goltzius so as to establish him at the summit of the Netherlandish school, just as van Mander's Italian counterpart, Giorgio Vasari, had placed Michelangelo at the apex of the Italian school.[23]

Shortly after his arrival in Haarlem in 1583, van Mander introduced Goltzius to the drawings of Bartholomeus Spranger (1546–1611), whom van Mander had befriended in Rome. Spranger was active at the court of Emperor Rudolph II in Prague, and his art was one of the primary catalysts for Mannerism in Northern Europe. Spranger's influence on Goltzius was decisive: between 1585 and his departure for Italy late in 1590, he produced seven engravings based directly on drawings supplied by Spranger (for example, *The Wedding of Cupid and Psyche,* fig. 29). This extremely fertile period for Goltzius also gave rise to his remarkable chiaroscuro woodcuts (figs. 17, 47, and 55) and marked the beginnings of a resonance between his prints and Tetrode's bronzes.

At the end of October 1590, Goltzius traveled to Italy, passing through Munich and visiting Rome, Naples, Venice, and Florence. This trip acquainted him with the art of his Italian contemporaries and also afforded him the opportunity to make extensive drawings after antique sculpture.[24] After his return to Haarlem in late 1591, these drawings eventually served as the basis

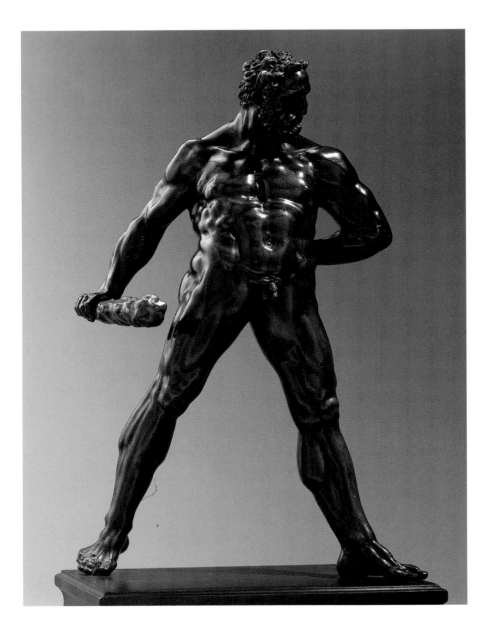

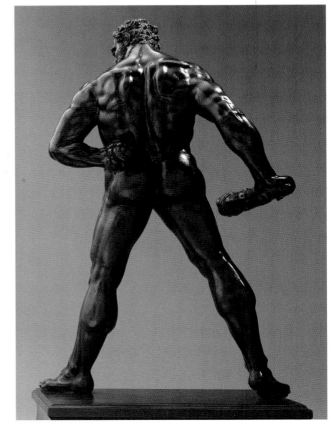

FIGS. 4, 5. Willem Danielsz.
van Tetrode, *Hercules Pomarius,*
c. 1547–65. Bronze, height
15 1/2 inches (39.4 cm).
Collection of the Hearn
Family Trust

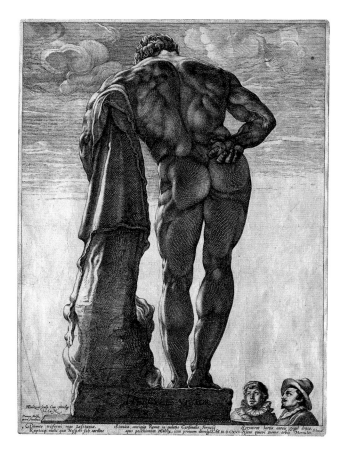

FIG. 6. Hendrick Goltzius,
The Farnese Hercules, c. 1592.
Engraving, 16 7/16 x 11 13/16
inches (41.8 x 30 cm). Collection
of the Hearn Family Trust

for his remarkable engravings of three antique sculptures, *The Farnese Hercules, The Apollo Belvedere,* and *Hercules and Telephos* (figs. 6, 34, and 36). This second period of intense printmaking, in which Goltzius produced his famous series of six engravings showing scenes of the early life of the Virgin (figs. 31–33), lasted until 1600, after which Goltzius focused his attention almost exclusively on painting, perhaps in part because of his failing eyesight. Despite some success as a painter, Goltzius's reputation, like that of Dürer, is based almost exclusively upon his achievements as a graphic artist.

GOLTZIUS AND TETRODE

The suggestion that Tetrode's complex muscled figures exhibiting an elegant wound-up torsion may have influenced Goltzius's conception of the human form, especially prior to the latter's departure for Italy in 1590, originated in a few straightforward comparisons. This hypothesis was first fully articulated in 1985 by Radcliffe, who argued that Tetrode's bronzes were the direct source for several of Goltzius's compositions.[25] According to this theory, Tetrode's *Hercules Pomarius* (figs. 4, 5), in which Hercules holds the golden apples of the Hesperides behind his back, seems to have been especially significant. In turn, Tetrode had clearly based his bronze in part upon *The Farnese Hercules* (fig. 6). Tetrode's bronze can be seen as a source for several of Goltzius's compositions, such as his 1589 engraving dubbed *The Great Hercules* by van Mander (fig. 7).[26]

Radcliffe points out that the 1624 inventory of the collection of the Delft goldsmith Thomas Cruse includes, among the bronzes and molds by

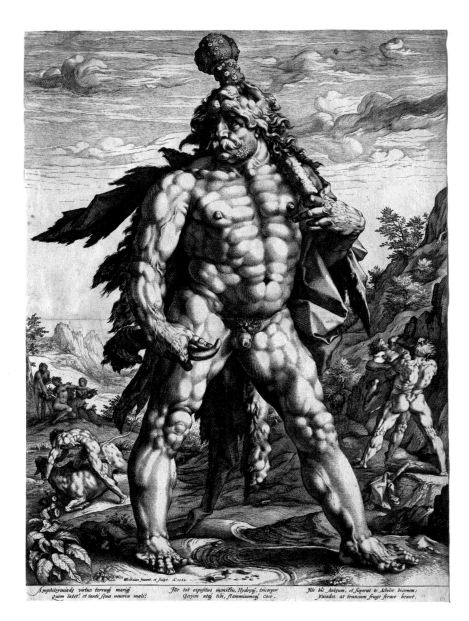

FIG. 7. Hendrick Goltzius, *The Great Hercules,* dated 1589. Engraving, 21 13/16 x 15 3/4 inches (55.4 x 40 cm) trimmed. Collection of the Hearn Family Trust

FIG. 8. Hendrick Goltzius, *Mars,* c. 1589. Red chalk, 14 1/8 x 10 5/8 inches (35.9 x 27 cm). Musée des Beaux-Arts et d'Archéologie, Besançon

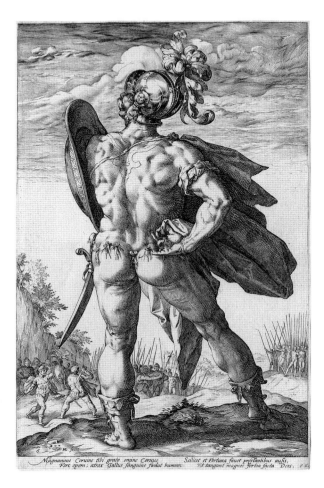

FIG. 9. Hendrick Goltzius, *Marcus Valerius Corvus,* from *The Roman Heroes,* c. 1586. Engraving, 14 5/8 x 9 1/4 inches (37.1 x 23.5 cm). Collection of the Hearn Family Trust

Tetrode, "1 form van den groten hercules van W. Tettero" (one mold of Tetrode's great Hercules).[27] The coincidence of the titles of both sculpture and engraving is intriguing. While it is possible that a lost Tetrode bronze, a *Great Hercules,* corresponded more exactly to Goltzius's *Great Hercules,* Tetrode's *Hercules Pomarius* offers several points of comparison.[28] The stance, musculature, extended right arm, and flexed left arm are common to both. While clearly not a copy of Tetrode's sculpture, Tetrode's bronze could have served as a point of departure for Goltzius. This is reinforced by the resonance of Tetrode's *Hercules Pomarius* in other works by Goltzius. As Radcliffe has noted, the back of Tetrode's bronze corresponds to Goltzius's chalk drawing of Mars in Besançon (fig. 8, ultimately engraved by Matham). This vantage point of Tetrode's bronze also animates the stance of Goltzius's chiaroscuro woodcut *Pluto* (fig. 55) and his engraving of Marcus Valerius Corvus (fig. 9) from the series *The Roman Heroes.* The bronze figure's left side approximates that of the figure of Herod in Goltzius's unfinished plate *The Massacre of the Innocents* (fig. 41) or of his half-length chiaroscuro woodcut *Mars* (fig. 47). Finally, two of the engravings designed by Goltzius for a 1589 edition of Ovid's *Metamorphoses* (figs. 64, 65) feature figures with powerful builds (Mars and Saturn) that correspond closely to the torso and stance of the *Hercules Pomarius* as seen from the front and the back (figs. 4, 5).

Tetrode's *Nude Warrior* (fig. 10)—which may actually be an image of Saturn or another deity—also seems to underlie several of Goltzius's engravings in the series *The Roman Heroes* (figs. 9, 11, and 12) and is especially close to the hero *Calphurnius* (fig. 12). The arm gestures and flying hair of the

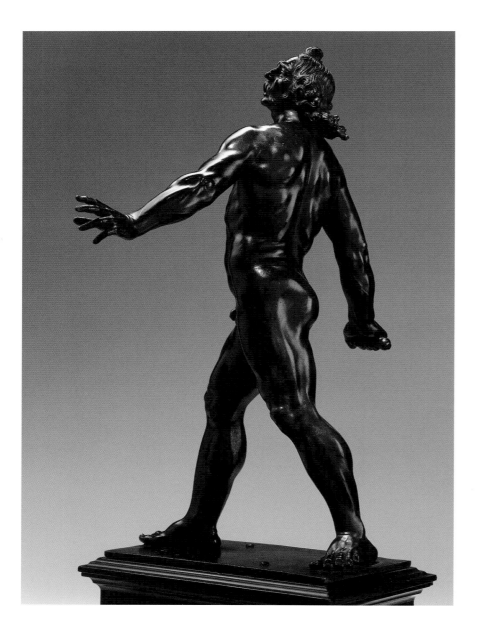

FIG. 10. Willem Danielsz. van Tetrode, *Nude Warrior/Deity,* 1565–75. Bronze, height 15 3/4 inches (40 cm). Collection of the Hearn Family Trust

FIG. 11. Hendrick Goltzius, frontispiece to *The Roman Heroes,* dated 1586. Engraving, 14 1/2 x 9 1/4 inches (36.8 x 23.5 cm) trimmed. Collection of the Hearn Family Trust

FIG. 12. Hendrick Goltzius, *Calphurnius,* from *The Roman Heroes,* c. 1586. Engraving, 14 5/8 x 9 1/4 inches (37.1 x 23.5 cm). Collection of the Hearn Family Trust

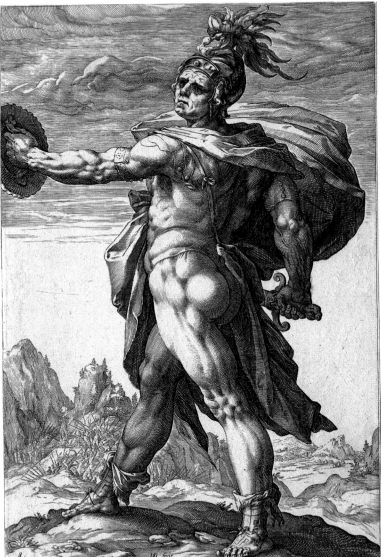

Nude Warrior/Deity also correspond to several of Goltzius's compositions, the stances of which were already discussed in relation to the *Hercules Pomarius*: two designs for Ovid's *Metamorphoses* and, to a lesser degree, the chiaroscuro woodcut *Pluto*. The engravings for the *Metamorphoses* are especially intriguing because each seems to be an amalgam of the *Hercules Pomarius* and the *Nude Warrior/Deity*. A careful examination shows that the figure of Mars seen from the front (fig. 64) takes his legs from the *Hercules Pomarius* and his torso from the *Nude Warrior/Deity*, and, similarly, the figure of Saturn seen from the back (fig. 65) corresponds to *Hercules Pomarius* from the waist down and to the *Nude Warrior/Deity* in its torso and arms.[29]

Numerous compelling comparisons between Tetrode's *Hercules and Antaeus* (figs. 13, 14) and Goltzius's oeuvre also emerged in the process of preparing this catalogue (see the essay by James Ganz). The relationship with other Tetrode bronzes seems so far to be less emphatic, although Radcliffe observed that the bronze *Mercury* in the Bargello (fig. 15) is close to the figure of Mercury designed by Goltzius and engraved by his stepson, Jacob Matham (1571–1631), in 1597 (fig. 16).[30] Unfortunately, the significance of Tetrode's lost bronzes cannot be adequately assessed through reproductive prints. The Jupiter, in de Weerdt's engraving (fig. 3), for example, would seem to build on the powerful form and stance of the *Hercules Pomarius* and the wild hair and arm gestures of the *Nude Warrior/Deity*, but we are not certain if the engraving actually represents a bronze or not.[31] The importance of the *Hercules Pomarius,* the *Nude Warrior/Deity,* and *Hercules and Antaeus* for Goltzius around 1586–90, however, is secure. Radcliffe concludes that

FIGS. 13, 14. Willem Danielsz. van Tetrode, *Hercules and Antaeus,* c. 1570. Bronze, height 20 1/2 inches (52 cm). Collection of the Hearn Family Trust

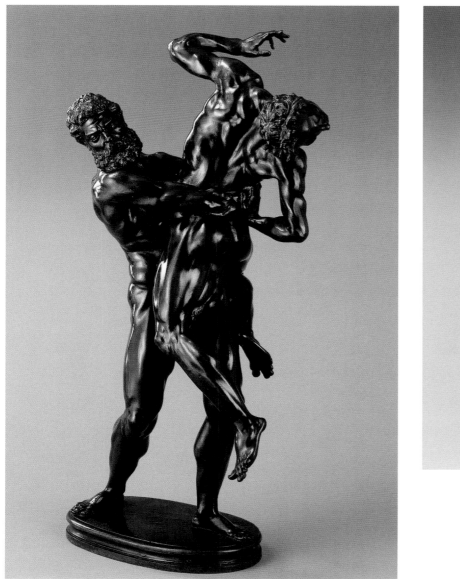

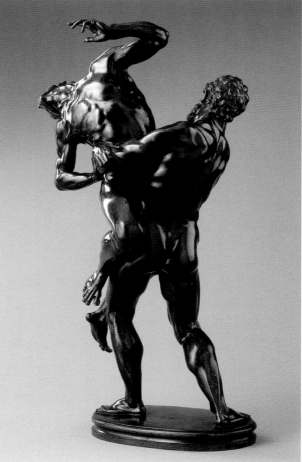

"when Willem van Tetrode left Delft for Cologne in 1574, he left behind him a substantial group of highly original bronzes, and that at least some of these became known by the late 1580s to Goltzius, who drew on them for his graphic work: indeed their discovery might well have triggered off a new phase in Goltzius's work which we can note at about this time."[32] This hypothesis, which might be expanded to allow for Tetrode's bronzes reaching Goltzius through avenues other than Delft, is compounded by the possibility that Tetrode had some significance not only for Goltzius but for the putative "Haarlem Academy" as well.

The 1618 edition of Karel van Mander's *Schilder-boeck* included a biography of the author that was probably composed by his son, Karel van Mander the Younger, or by his youngest brother, Adam van Mander.[33] From this biography we learn that the close-knit group of artists Cornelis Cornelisz. van Haarlem (1562–1638), Karel van Mander, and Goltzius worked together "after life," which, as Pieter van Thiel has argued, seems to refer to drawing from real objects, as opposed to drawing from the imagination: "Soon afterwards Karel became acquainted with Goltzius and Master Kornelis, and these three held and formed an academy for studying from life. Karel showed them the Italian manner, which is seen to good effect in the Ovid of Goltzius."[34] While the exact nature of this purported "academy" has never been clearly understood, evidence suggests that van Mander, Goltzius, and Cornelis had access to sculptural models among their study materials.[35] Van Mander testifies that Cornelis had recourse to "antique sculpture" in some form: "Meanwhile Cornelis greatly assisted his

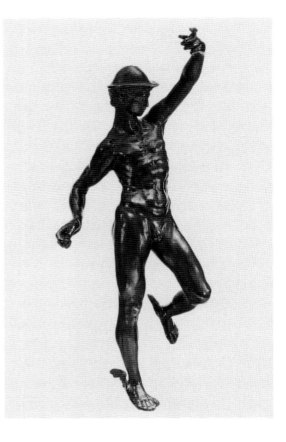

FIG. 15. Willem Danielsz. van Tetrode, *Mercury,* c. 1560. Bronze, height 23 5/8 inches (60 cm). Museo Nazionale del Bargello, Florence

FIG. 16. Jacob Matham after Hendrick Goltzius, *Mercury*, from *The Planets,* 1597. Engraving, 4 11/16 x 3 1/16 inches (11.8 x 7.7 cm). Collection of the Hearn Family Trust

ambitious nature through drawing an exceptional amount from life—to which end he chose from the best and most beautiful living and breathing antique sculptures of which we have plenty in this country, for that is the surest and very best study that one can find, at least if one has perfect judgment in distinguishing the most beautiful from the beautiful."[36] It would seem possible that among the "beautiful living and breathing antique sculptures" Cornelis studied would have been Tetrode's bronzes, such as those after antique prototypes (figs. 1, 2). Van Thiel argues that while van Mander's passage might include a joke about beautiful living Dutch models, his sense was probably that the artists worked from "animated, true to life (instructive) antique sculptures" and that these antique sculptures most likely amounted to "depictions in the form of prints, drawings made in Rome, and plaster casts."[37] There is evidence that the Italian artist Gaspare Celio (1571–1640) provided Goltzius with drawings of Italian antiquities and works by Raphael, but this can only be dated with certainty after his trip to Italy.[38] More concrete evidence is given by Van Thiel, who cites an inventory of Cornelis's shop that lists over 100 sculptural works, including many plaster casts.[39] Although there is no mention of Tetrode in this inventory, Cornelis made use of Tetrode's *Hercules Pomarius* as a model for his paintings on one or two occasions.[40]

A key image in understanding Goltzius's uses of contemporary and historical models is his superb chiaroscuro woodcut of 1588, *Hercules and Cacus* (fig. 17). The figure of Hercules seems to be a conflation of Tetrode's *Hercules Pomarius* and his *Hercules and Centaur* (fig. 18) and indeed, it may

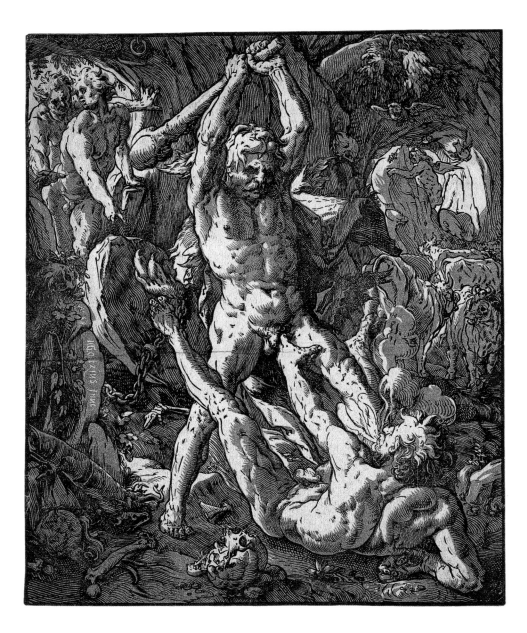

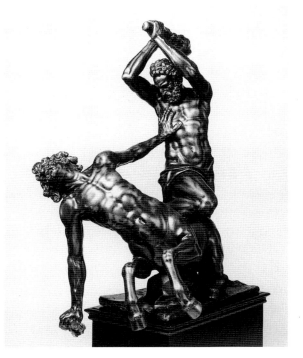

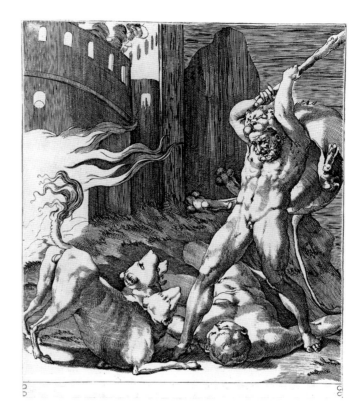

FIG. 17. Hendrick Goltzius, *Hercules and Cacus,* dated 1588. Chiaroscuro woodcut, 16 x 13 1/16 inches (40.6 x 33.1 cm). Collection of the Hearn Family Trust

FIG. 18. Willem Danielsz. van Tetrode, *Hercules and Centaur,* c. 1560. Bronze, height 17 11/16 inches (45 cm). Private Collection, United States

FIG. 19. Giovanni Jacopo Caraglio after Rosso Fiorentino, *Hercules Battling Cerberus,* 1524. Engraving, 8 3/4 x 7 13/16 inches (22.2 x 18.3 cm). The British Museum, London

owe something to them. However, as Ger Luijten has shown, the posture of Hercules derives rather directly from a 1524 engraving, *Hercules Battling Cerberus* (fig. 19), by Giovanni Jacopo Caraglio (c. 1500–1565) after Rosso Fiorentino (1494–1540).[41] Cacus's right arm tucked behind his back also recalls the left arm of the *Hercules Pomarius,* but Van Thiel argues persuasively that Cacus is actually derived from Cornelis's painting *The Dragon Devouring the Companions of Cadmus,* which, like the engraving after it by

Goltzius (fig. 20), dates to 1588. Further, the foreshortened view of Cacus recalls the *Torso Belvedere* (fig. 21), which both Cornelis and Goltzius could have known through the *Roman Sketchbooks* of Maarten van Heemskerck (1458–1574), then in the possession of Cornelis.[42] Heemskerck's drawing shows the first-century B.C. *Torso Belvedere* lying on the ground as it appeared around 1535, prior to being set up on its base in the mid-sixteenth century.[43]

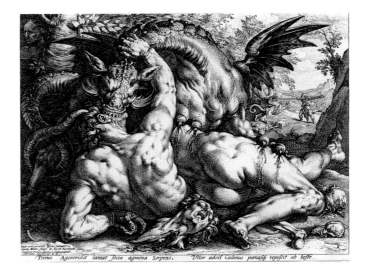

Acknowledging these apparent compositional sources in Caraglio, Heemskerck, and Cornelis, the question arises as to what, if any, role Tetrode did play. One might seek the gesture of Cacus's arm bent behind his back in the analogous gesture in the *Hercules Pomarius,* but in reference to *The Dragon Devouring the Companions of Cadmus,* Van Thiel notes that "this motif apparently comes from Michelangelo's *Giorno* (Florence, San Lorenzo, Medici Chapel), of which Cornelis owned a model."[44] In this instance Tetrode seems to have provided Goltzius with a general reference to rendering musculature. Neither Cornelis nor Caraglio offered Goltzius such a model for his fully flexed figures. Heemskerck has sometimes been suggested as a source for Goltzius's approach to musculature, and while Heemskerck, like Cornelis Cort (1533–1578), provided important precedence for rendering muscled figures, Tetrode provides the most compelling visual model.[45] Tetrode's bronzes, especially as seen in raking light, are animated by shadows cast by his heavily modeled forms and highlights created by the play of light on their lustrous surfaces. Compared to Goltzius's complex renderings of musculature, Heemskerck's are overwrought and Caraglio's are flaccid.

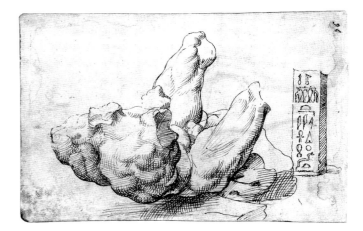

Although many of the works in this exhibition are engravings, the technique of chiaroscuro woodcut, used in *Hercules and Cacus,* provides an excellent two-dimensional analogue to sculptural features of Tetrode's bronzes. Chiaroscuro woodcut relies on conveying form through the combination of middle tones, dark outlines, and highlights. The middle tones and outlines are each printed from separately carved wooden blocks while the highlights are actually areas that have been carved out of all of the blocks, leaving them uninked and allowing the pristine tone of the paper to shine through.

While Goltzius's chiaroscuro woodcuts are a special case, his engravings, as well as those by the artists who worked under his influence, were tour-de-force demonstrations of the rendering of three-dimensionality. Where the technique of chiaroscuro woodcut excels at capturing the play of light on a surface, engraving attains a more dazzling resolution with its purely linear and monochromatic systems of swelling and tapering lines incised by the burin. When Cornelis referred to Tetrode's *Hercules Pomarius* as a model for Ulysses in his painting *Ulysses and Irus* (location unknown), he smoothed over Tetrode's highly animated surfaces. Yet these same passages provided a catalyst for Goltzius, whose masterful line work excelled in the rendering of undulating surfaces. In fact this mastery of musculature is the primary visual theme of Goltzius's *Roman Heroes* (figs. 9, 11, 12, 22–25). It is fitting that when Goltzius's follower Jan Muller (1571–1628) engraved Cornelis's *Ulysses and Irus* (fig. 26), a print published by Goltzius in 1589, he used Goltzius's approach to musculature.[46]

FIG. 20. Hendrick Goltzius, *The Dragon Devouring the Companions of Cadmus,* dated 1588. Engraving, 9 13/16 x 12 1/2 inches (25 x 31.8 cm). Collection of the Hearn Family Trust

FIG. 21. Maarten van Heemskerck, *Torso Belvedere,* from *Roman Sketchbooks* (vol. 1, fol. 63r), c. 1535. Drawing, 5 3/16 x 8 1/4 inches (13.1 x 21 cm). Kupferstichkabinett, Staatliche Museen zu Berlin-Preussischer Kulturbesitz

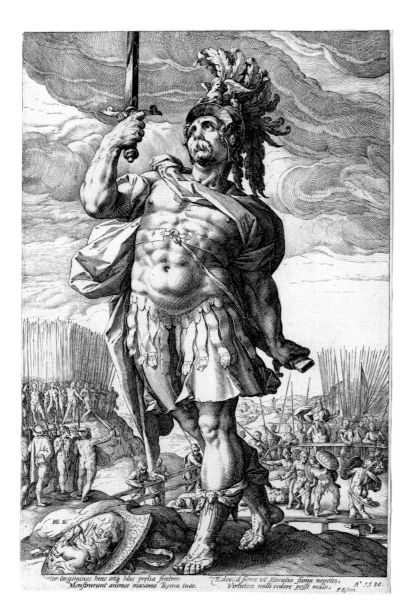

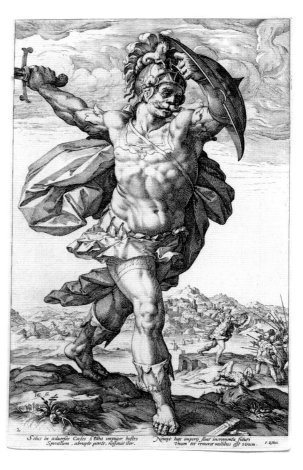

FIG. 22. Hendrick Goltzius, *Publius Horatius,* from *The Roman Heroes,* dated 1586. Engraving, 14 5/8 x 9 1/4 inches (37.1 x 23.5 cm). Collection of the Hearn Family Trust

FIG. 23. Hendrick Goltzius, *Horatius Cocles,* from *The Roman Heroes,* c. 1586. Engraving, 14 5/8 x 9 5/16 inches (37.1 x 23.6 cm). Collection of the Hearn Family Trust

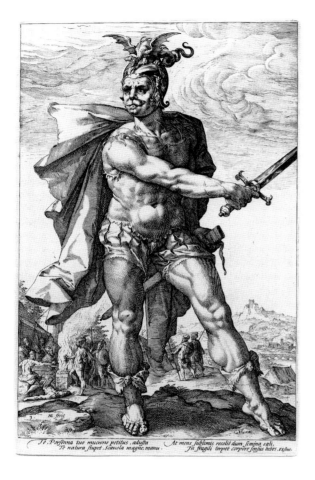

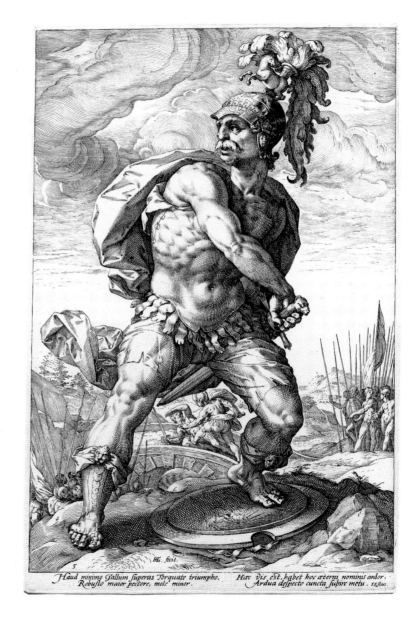

FIG. 24. Hendrick Goltzius, *Caius Muscius Scaevola,* from *The Roman Heroes,* c. 1586. Engraving, 14 5/8 x 9 1/4 inches (37.1 x 23.5 cm). Collection of the Hearn Family Trust

FIG. 25. Hendrick Goltzius, *Titus Manlius Torquatus,* from *The Roman Heroes,* c. 1586. Engraving, 14 5/8 x 9 1/4 inches (37.1 x 23.5 cm). Collection of the Hearn Family Trust

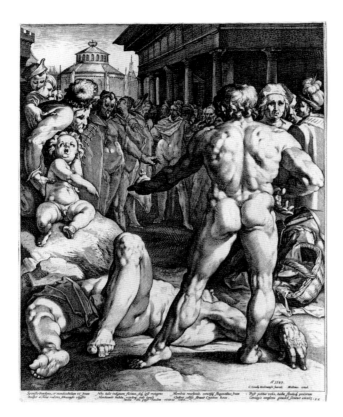

We can be certain that Goltzius was sensitive to the virtues of examin-
ing sculpture from numerous vantage points—the kind of viewing that
Cellini espoused and must have impressed upon Tetrode. For example,
Goltzius's interest in moving around sculpture is clearly expressed during
his trip to Italy in his own studies of the *Torso Belvedere* as seen from two
distinct angles (figs. 37, 38), as it is in his engravings of antique sculpture
discussed below. Cornelis, who provided Goltzius with a number of com-

FIG. 26. Jan Muller after Cornelis
Cornelisz. van Haarlem, *Ulysses
and Irus,* 1589. Engraving, 19 3/16
x 13 1/16 inches (47.7 x 33.2 cm).
Collection of the Hearn Family
Trust

FIG. 27. Hendrick Goltzius
after Cornelis Cornelisz. van
Haarlem, *Phaeton,* from *The
Four Disgracers,* c. 1588.
Engraving, diameter 12 15/16
inches (32.9 cm). Collection of
the Hearn Family Trust

FIG. 28. Hendrick Goltzius
after Cornelis Cornelisz. van
Haarlem, *Ixion,* from *The Four
Disgracers,* c. 1588. Engraving,
diameter 13 1/16 inches (33.1
cm). Collection of the Hearn
Family Trust

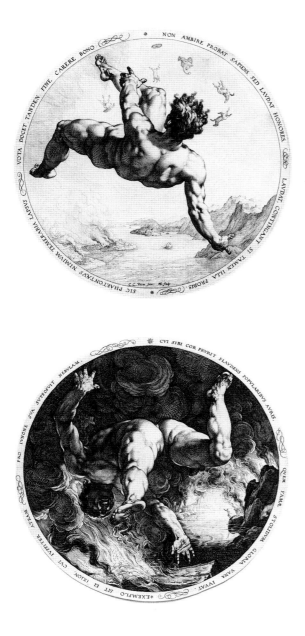

positions, was deeply preoccupied with moving around the human figure. For example, *The Four Disgracers,* designed by Cornelis but shown here through Goltzius's engravings after them, depict figures as if tumbling through space. *Icarus* and *Phaeton* (fig. 27) are arguably the same figure seen from two directions (with the hand gestures modified) and *Ixion* (fig. 28) is a reflection of *Icarus* with a further modification of the arms. Analogues for all four *Disgracers* can also be found in Cornelis's painting *Titanomachina* (c. 1588, Statens Museum for Kunst, Copenhagen).

SCULPTURE, PRINTMAKING, AND VIRTUOSITY

Reproductive printmaking—prints executed after the designs of other masters—formed a large part of the output of any professional printmaker in the late sixteenth century, a time when the practice was not tainted with the pejorative connotations that today might be ascribed to "copying." After all, it was largely through his engravings, many of which are either informed by the work of other artists or unabashedly based on the compositions of others, that Goltzius acquired his towering stature within the artistic pantheon elaborated by van Mander. As Dorothy Limouze has shown, Engraving, Painting, and Drawing appear in the guise of the three graces in the allegorical framework in Jacob Matham's engraved portrait of Goltzius, with the standing figure of Engraving at the summit.[47] Melion has fully documented the high esteem in which reproductive engravers were held in Goltzius's day. For example, when Goltzius's teacher, Coornhert, wrote a letter to

29

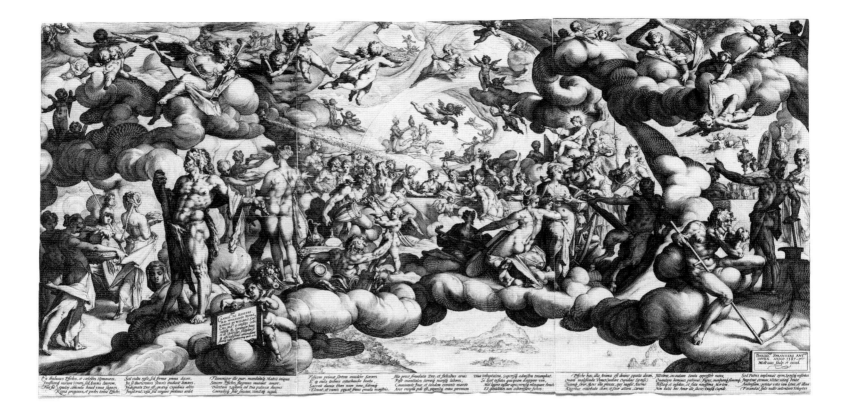

Abraham Ortelius to express thanks for an engraving by Philips Galle (1537–1612) after a composition by Pieter Bruegel (c. 1525–1569), Coornhert was careful to "bestow equal praise on Bruegel and Galle, commending the draftsmanship of the one and the burin-work of the other."[48] Similarly, van Mander states that Goltzius's engraving after Spranger's *Wedding of Cupid and Psyche* (fig. 29) "overflows with the sweet and appealing Nector, and which offers equal immortality to the designer and the engraver."[49] Melion also makes a case that reproductive engraving was appreciated within humanist circles on the grounds that a reproductive print could be as virtuous as an excellent translation of a Greek or a Latin text.[50] Tetrode might well have seemed especially worthy of "translation" for the artists in Goltzius's circle, given his twenty years of firsthand experience in Italy working with antiquities and with some of the most progressive artists of his day. For Goltzius, however, Tetrode's allure may have gone beyond lessons of Italy and antiquity to the challenge of rendering three dimensions in two.

Discussions of Goltzius as a virtuoso printmaker have focused almost exclusively on his engravings. If knowledge of Goltzius relied solely on van Mander's extensive text in the *Schilder-boeck,* it would not be clear that he had ever made chiaroscuro woodcuts. Martin Kemp exemplifies the praise of Goltzius as engraver: "The exploitation of astonishingly regular curved parallels to create tone, to describe internal contour in terms of implied motion of line, and to make staccato patterns had become something of a hallmark of engravers working for Hieronymus Cock, and was developed to virtuoso extremes by the greatest draftsman-engraver of the turn of the century,

FIG. 29. Hendrick Goltzius after Bartholomeus Spranger, *The Wedding of Cupid and Psyche,* dated 1587. Engraving, 16 13/16 x 33 7/16 inches (42.7 x 85 cm). Collection of the Hearn Family Trust

31

Hendrick Goltzius."[51] Melion located Goltzius's virtuosity in two specific phases of the printmaker's career: his response to the example of Spranger prior to his travels in Italy, and, after his return to Haarlem, his "meester-stukjes" (masterpieces), the six plates of *The Life of the Virgin* of 1593–94.[52]

Once introduced to Spranger's drawings by van Mander, Goltzius set about adapting the syntax of engraved lines to Spranger's elegant forms. Building on the engraving techniques developed by his predecessors, Goltzius tightened the relationship between engraved lines and the underlying forms they sought to describe. As Melion happily phrased it in describing Goltzius's 1587 engraving after Spranger's pen, ink, and wash drawing *The Wedding of Cupid and Psyche* (fig. 29): "Both the plate's mode of production, which involves the orbital manipulation of the working surface, and its constituent lines, whose flexion inscribes notional spirals, become correlatives to the torsion of Sprangher's figures."[53] Even before such achievements as *The Wedding of Cupid and Psyche,* Goltzius began to shift from the reproduction of Spranger's compositions to working independently in the manner of Spranger. Lee Hendrix identified Goltzius's *Mars and Venus Surprised by Vulcan* of 1585 (fig. 30), which owes its languorous figures and twisting postures to Spranger, as the print in which Goltzius began working in Spranger's style without recourse to a specific drawing by Spranger.[54] Nonetheless, Goltzius would continue to copy Spranger until 1588, by which time his interests were already shifting from a preoccupation with Spranger's elegant forms to the more substantial types offered by Tetrode. However deft Goltzius's mastery of Spranger may seem, it is only a prelude

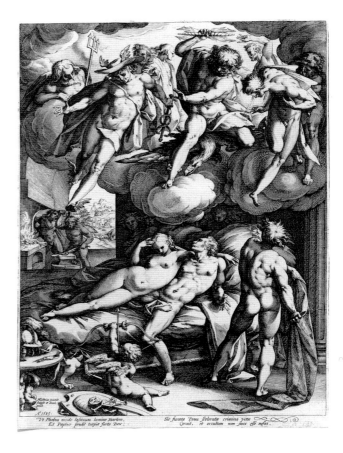

FIG. 30. Hendrick Goltzius, *Mars and Venus Surprised by Vulcan,* dated 1585. Engraving, 16 1/2 x 12 3/16 inches (42 x 31 cm). Collection of the Hearn Family Trust

to his understanding of other artists' styles as it would emerge in the 1590s.

After his return from Italy Goltzius solidified his reputation with the dazzling display of technical skill and historical grasp of art he demonstrated with his six sheets of *The Life of the Virgin*. In each of these engravings Goltzius transmogrifies his artistic identity to demonstrate a rigorous understanding of a different artistic personality. The most highly acclaimed of these accomplishments are the sheets in the manner of Dürer and Lucas van Leyden (1494–1533) showing *The Circumcision* and *The Adoration of the Magi*, respectively (figs. 31, 32). The remaining sheets evoke the styles of Italian masters but not in as direct and monographic a sense as in the sheets after Dürer and Lucas. The stylistic readings that generally prevail are that *The Annunciation* (fig. 33) draws inspiration from both Federigo Barocci (1528–1612) and Taddeo Zuccaro (1529–1566), *The Visitation* speaks primarily in the voice of Parmigianino, *The Adoration of the Shepherds* is in the manner of Jacopo Bassano (c. 1510–1592), and *The Holy Family with the Infant Saint John the Baptist* betrays the style of Barocci.[55]

Goltzius's remarkable ability to assimilate styles widely separated temporally and geographically and to bring them forth through the singular medium of engraving was not lost on his contemporaries. Nicholas Hilliard (1537–1619), the English miniaturist and author of the *Art of Limning* (Art of Painting), noted in 1600 that Goltzius "approched Albertus very neer," that he imitated Lucas's "handling [of] the graver," but that he also "afecteth another maner of line, which is swifter acording to his spirit, and doubtless very excelent and most followed."[56] Only a few years later van Mander

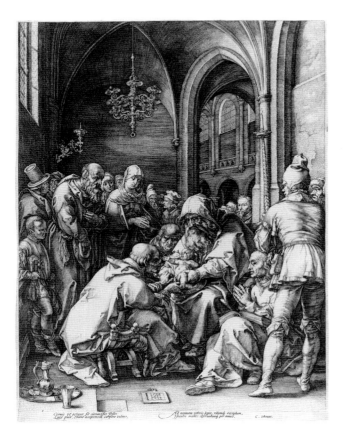

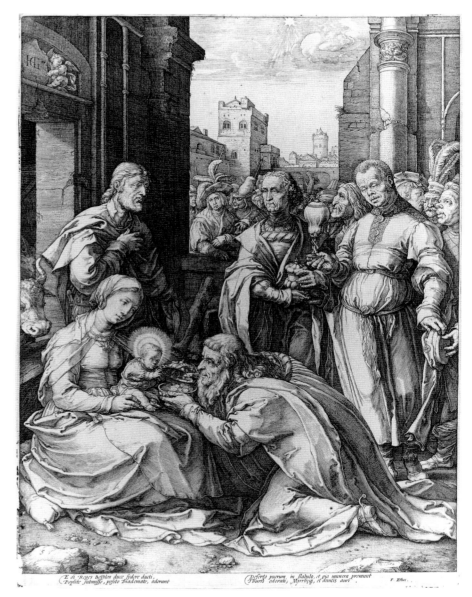

FIG. 31. Hendrick Goltzius, *The Circumcision,* from *Life of the Virgin,* 1594. Engraving, 18 5/8 x 13 7/8 inches (47.3 x 35.2 cm). Spencer Museum of Art, The University of Kansas, Lawrence

FIG. 32. Hendrick Goltzius, *The Adoration of the Magi,* from *Life of the Virgin,* 1593–94. Engraving, 18 11/16 x 14 inches (47.5 x 35.5 cm). Spencer Museum of Art, The University of Kansas, Lawrence. Letha Churchill Walker Memorial Art Fund

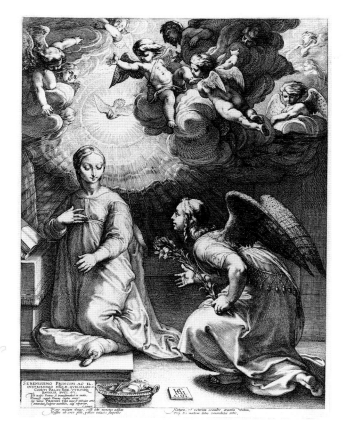

FIG. 33. Hendrick Goltzius, *The Annunciation,* from *Life of the Virgin,* 1594. Engraving, 19 1/16 x 14 3/16 inches (48.5 x 36.1 cm). Spencer Museum of Art, The University of Kansas, Lawrence. Letha Churchill Walker Memorial Art Fund

described Goltzius as "a rare Proteus (the classical god of constantly shifting shapes), or Vertumnus (another metamorphic figure) of art."[57] Van Mander's reference to Proteus was based directly on the laudatory inscription on the first plate of *The Life of the Virgin* (fig. 33). This engraved text, which immediately follows the dedication of the series to Duke Wilhelm V of Bavaria, underscores Goltzius's chameleonlike display. Melion summarizes: "The epithet Proteus-Vertumnus derives from the dedication quatrain inscribed on the Annunciation, the opening plate of the *Life of the Virgin.* Composed by Cornelius Schoneus, rector of the Latin school of Haarlem, the dedication purposely mixes metaphors, claiming that 'just as Proteus, captivated by eager love for the graceful Pomona, transformed himself in the midst of the waves,' so too, 'through his immutable art Goltzius, astonishing engraver and inventor, transforms himself.'"[58] If we think of Goltzius as a Proteus—an artist whose core sense of virtuosity involves the notion of assimilating all that is great that has gone before him—then the issue of responding to sculpture takes on a special significance. It could be that Goltzius strove not only to master the lessons of painters and printmakers (Dürer, Lucas, Barocci, Spranger, and others), but also to find a means of assimilating in his graphic inventions the lessons of three-dimensional forms.

Once in Italy Goltzius drew extensively from Roman antiquities and his studies resulted in a group of three engravings after antique sculpture. These engravings, executed around 1592 and published in 1597, are *The Farnese Hercules, The Apollo Belvedere,* and *Hercules and Telephos* (figs. 6, 34, and 36). Since he had probably seen Heemskerck's *Roman Sketchbook* and Cornelis's collection

35

of sculpture and plaster casts, and, evidently, knew of Tetrode, Goltzius's studies from antique sculpture in Italy may have been more an act of confirmation than one of revelation. Nonetheless, they involved an active process that had many ramifications on his work as a graphic artist.

Two of the engravings of antique sculpture demand that the viewer not only consider the sculpture itself, but also observe the sculpture in the round. Goltzius's print depicts *The Farnese Hercules* from the back—the viewer's eyes inevitably mesmerized by the swirling moiré patterns of Hercules' buttocks. The print also reveals two observers (often identified as Goltzius and his stepson Jacob Matham), who study the sculpture from the front. Moving around the sculpture to admire it from various angles provides views that were doubtless well known to Goltzius, as they also inspired Tetrode's *Hercules Pomarius.*

Similarly, when Goltzius engraved *The Apollo Belvedere* (fig. 34) he could not resist inserting the likeness of an artist in intense concentration transposing the sculpture from three dimensions to two. This is not the only time that Goltzius depicted an artist contemplating a sculpture. Within a year of his series of antique sculpture he engraved *Pygmalion and Galatea* (fig. 35), a rendering of the myth of a king who fell in love with the sculpture he had carved. For the figure of Galatea, Goltzius offers a recollection of an antique statue of Venus, which is fitting, as it was Venus who brought the statue to life in the form of Galatea.[59] Of the three antique sculptures, only *Hercules and Telephos* (fig. 36) is shown simply as a "portrait" of a sculpture rather than as an object engaging the attention of a viewer.

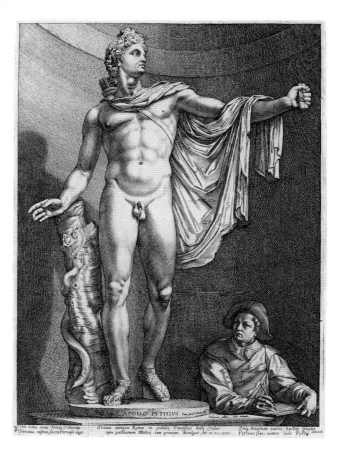

FIG. 34. Hendrick Goltzius, *The Apollo Belvedere,* c. 1592. Engraving, 16 5/16 x 11 13/16 inches (41.5 x 30 cm). Collection of the Hearn Family Trust

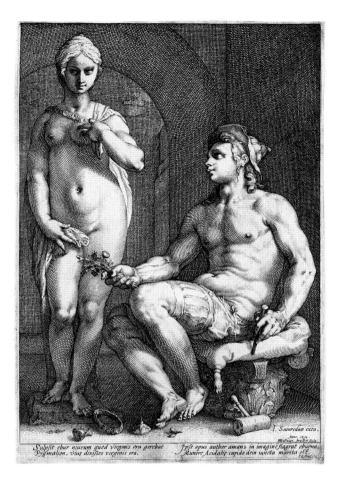

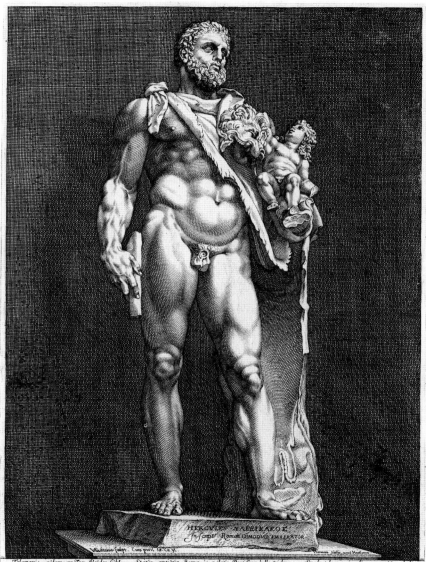

FIG. 35. Hendrick Goltzius, *Pygmalion and Galatea,* dated 1593. Engraving, 12 15/16 x 8 9/16 inches (32.8 x 21.7 cm). Collection of the Hearn Family Trust

FIG. 36. Hendrick Goltzius, *Hercules and Telephos,* c. 1592. Engraving, 16 3/8 x 11 7/8 inches (41.7 x 30.1 cm). Collection of the Hearn Family Trust

The question arises as to why an artist whose sense of virtuosity springs from the perfection of the manner of great artists became so engrossed with the problems posed by sculpture. One possible answer involves the rhetorical "paragone debates" of the Renaissance that sought to discover whether painting or sculpture was the superior art form. The term *paragone* (from "paragonare," to test on a touchstone) derives from the title ascribed only in 1817 to Leonardo da Vinci's famous text claiming the superiority of painting over other art forms.[60] Leonardo did not originate such debates, however; Erwin Panofsky argues that their origins may be found in medieval literature contests and in the ancient Greek "passion for debate." The debates began in earnest around 1500, when the painter Cennino Cennini (c. 1370– c. 1440) argued that painting should be included among the liberal arts. By the mid-sixteenth century they had become "a kind of intellectual pastime,"[61] one that was kept alive right up to Goltzius's day.

Tetrode's Florentine employer Benvenuto Cellini participated in the most famous paragone debate. He was one of eight prominent artists who responded to a questionnaire about the virtues of painting and sculpture circulated by Benedetto Varchi (1503–1565) in 1546. Only Cellini applauded artists who blurred the distinctions between painter and sculptor, "warmly endors[ing] Michelangelo's skill as a painter and Bronzino's sculptural style."[62] While they are infrequent, a few passages in van Mander also suggest a familiarity with the paragone.[63] As late as 1612, however, even the astronomer Galileo was embroiled in the debates and apparently came to the rescue of the Florentine painter Lodovico Cardi da Cigoli (1559–1613) in

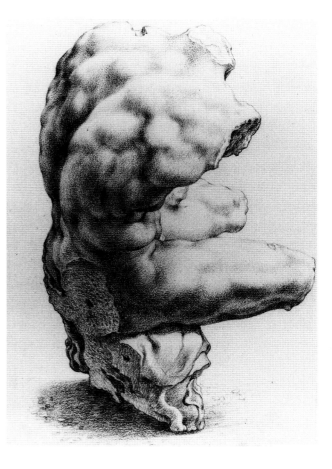

FIG. 37. Hendrick Goltzius, *Torso Belvedere* (side view), c. 1591. Black chalk, 9 15/16 x 6 7/8 inches (25.3 x 17.5 cm). Teylers Museum, Haarlem

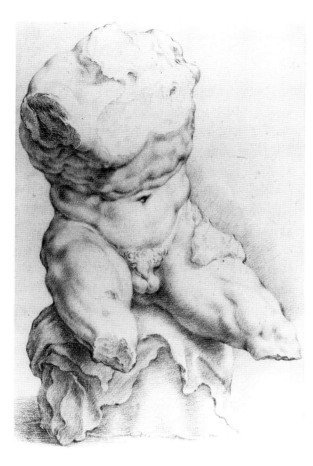

FIG. 38. Hendrick Goltzius, *Torso Belvedere* (frontal view), c. 1591. Black chalk, 10 1/16 x 6 9/16 inches (25.5 x 16.6 cm). Teylers Museum, Haarlem

framing a response for a paragone discussion. In his letter to Cigoli of 1612, Galileo concluded that "The most artistic imitation is that which represents the three-dimensional in its opposite, which is the plane."[64] This, of course, is exactly the task that occupies the artist depicted in Goltzius's *Apollo Belvedere* and in dozens of drawings of Roman statuary, such as the views of the *Torso Belvedere* illustrated here (figs. 37, 38). This same conceit is expressed in the praise offered by the Italian poet and art theorist Giambattista Marino (1569–1625) in commenting on a print by Francesco Villamena (1564–1624), who, like Goltzius, found inspiration in Cort and Barocci. As Eckhard Leuschner has noted, Marino wrote of Villamena's map of Rome that "the beholder of [Villamena's] print witnesses 'how, due to the virtue of artistic genius, the solidity of marble is surpassed by that of paper.'"[65]

Of Goltzius's three primary followers, Jacob Matham, Jan Muller, and Jacques de Gheyn II (1565–1629), Muller most closely emulated his master as an international virtuoso. On two occasions Muller produced series of engravings that offer multiple views of a sculpture by the Dutch artist Adriaen de Vries (c. 1556–1626). De Vries, who had studied with the Italian Mannerist sculptor Giambologna (1529–1608), and may have worked in Tetrode's studio in Delft between 1568 and 1574, was associated with the court of Emperor Rudolf II.[66] His first important imperial commission was the eight-foot-tall bronze of *Mercury and Psyche* of 1593 (fig. 39). Muller's engravings after this superb bronze (c. 1598; figs. 40A–C), like those after de Vries's *Rape of a Sabine,* encourage the viewer to take in multiple vantage points of a sculpture at a single glance.[67] Luijten asserts that "Muller seems to be making the

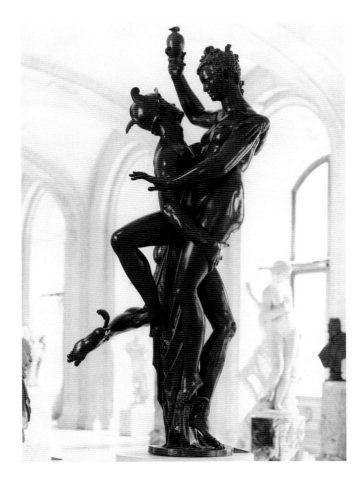

point that painting, or printmaking, is superior to sculpture because it has the capacity to represent sculpture with due observation of its three-dimensional nature." Limouze has cited Muller's prints as examples of "imagery that reflects on the notion of the *paragone*."[68] However, it would probably be a mistake to understand these prints, or Goltzius's *Farnese Hercules* and

FIG. 39. Adriaen de Vries, *Mercury and Psyche,* 1593. Bronze, height 98 7/16 inches (250 cm). Musée du Louvre, Paris

FIGS. 40A–C. Jan Muller after Adriaen de Vries, *Mercury Abducting Psyche,* dated 1593. Engraving, 21 7/8 x 10 1/16 inches (55.6 x 25.6 cm) each. Collection of the Hearn Family Trust

Apollo Belvedere (where the movement around the sculpture is implied rather than literal) as participating in the paragone debate in any literal sense. Rather, the paragone rhetoric assures us that the play between two- and three-dimensional mediums was an active concept around 1600, and one that artists might exploit to demonstrate their virtuosity. This was clearly one of Goltzius's objectives.

If we factor this concern for sculpture into our understanding of a career already bent on prodigious demonstrations of skill, we arrive at a consistent view of Goltzius. He appears as a printmaker par excellence, who furthered the achievements of Dürer in both engraving and woodcut and who co-opted painting in the name of the graphic arts through his large "penworks." Goltzius so mastered the lessons of other prodigies (Dürer, Lucas, and Spranger among them) that he could invent anew in their styles, simultaneously turning printmaking to the task of assimilating three dimensions into two. During the 1580s Goltzius must have had access to Tetrode's bronzes (most certainly the *Hercules Pomarius* and the *Nude Warrior/Deity),* as they evidently provided him with models for specific compositions. More significantly, however, Tetrode seems also to have provided Goltzius with a touchstone for an understanding of highly animated passages of musculature and must have nourished Goltzius's contemplation of the relationship between two- and three-dimensional rendering to which he returned later in his career. In all of these situations Tetrode participated in shaping Goltzius's talent and contributed to his ultimate status as an unparalleled virtuoso printmaker.

1. Amy Namowitz Worthen, "Calligraphic Inscriptions on Dutch Mannerist Prints," *Nederlands Kunsthistorisch Jaarboek* 42–43 (1991–92): 261–306.

2. For the "pen works," see Lawrence W. Nichols, "The 'Pen Works' of Hendrick Goltzius," *Philadelphia Museum of Art Bulletin* 88 (1992): 1–58.

3. Anthony Radcliffe, "Schardt, Tetrode, and Some Possible Sculptural Sources for Goltzius," in *Netherlandish Mannerism: Papers Given at a Symposium in Nationalmuseum Stockholm, September 21–22, 1984,* ed. Görel Cavalli-Björkman (Stockholm: Nationalmuseum, 1985), 97–108. Radcliffe credits the observation of a correspondence between Goltzius and Tetrode to a brief citation in Jaap Leeuwenberg and Willy Halsema-Kubes, *Beeldhouwkinst in het Rijksmuseum* (Amsterdam: Staatsuitgeverij, 1973), p. 167, no. 200.

4. An exhibition devoted to Tetrode is scheduled to open at the Rijksmuseum, Amsterdam, in 2003.

5. Wilhelmina Halsema-Kubes, "Tetrode, Willem Danielsz. Van," in *The Grove Dictionary of Art* (London: Macmillan, 1996), 30:530; Jaap Nijstadt, "Willem Danielsz. van Tetrode," *Nederlands Kunsthistorisch Jaarboek* 37 (1986): 259–79; and Jaap Nijstadt, "Willem Danielsz. van Tetrode 1525?–voor 1588?" in *Kunst voor de beeldenstorm,* eds. J. P. Filedt Kok et al., exh. cat. (Amsterdam: Rijksmuseum, 1996), 456–61. See also John Michael Montias, *Artists and Artisans in Delft: A Socio-Economic Study of the Seventeenth Century* (Princeton: Princeton University Press, 1982), 31–32. For a discussion of Tetrode's possible origins in Antwerp see K. G. Boon, "Vier tekeningen van Willem Danielsz. Tetrode," *Oud Holland* 80 (1965): 205–6.

6. For Ganymede and Perseus, see Halsema-Kubes, "Tetrode."

7. Volker Krahn, "Von allen Seiten schön," in *Von Allen Seiten Schön, Bronzen der Renaissance und des Barock,* ed. Volker Krahn, exh. cat. (Berlin: Staatliche Museen zu Berlin Preussischer Kulturbesitz, 1995), 10.

8. I thank Charles Hack for suggesting Tetrode's exposure to *The Farnese Hercules.* On Tetrode's supposed work on the *Neptune Fountain,* see, for example, Johannes Auersperg, *A Bronze Figure of the Hercules Pomarius by Willem Danielsz. van Tetrode* (London: Daniel Katz Ltd., 1996), 4. Anthony Radcliffe, in correspondence with Charles Hack, has clarified the issue of Tetrode and Ammanati: "The assignment of three of the bronze fauns on the Neptune fountain to Tetrode is pure conjecture—Venturi following suggestions by Kriegbaum made [this hypothesis] at a time when nothing was known of the real Tetrode and his work in Delft. Work on the bronze for the fountain began in March 1571, by which time Tetrode had been back in Delft for at least four years, and they were completed in 1575, by which time he had moved to Cologne."

9. Halsema-Kubes, "Tetrode." Excepting the Marcus Aurelius, whose location is unknown, Halsema-Kubes notes that the Tetrode bronzes were later presented to Cosimo I de' Medici and that all are now in the Museo Nazionale del Bargello, Florence.

10. Auersperg, "Hercules Pomarius," 4.

11. Ilja M. Veldman, "Keulen als toevluchtsoord voor Nederlandse kunstenaars (1567–1612)," *Oud Holland* 107, no. 1 (1993): 33–58.

12. Nijstadt, "Tetrode," 266n. 38, cites Buechelius, who mentions Tetrode bronzes in the collection of Apert Francen in Delft. Halsema-Kubes, in "Tetrode," 30:530–31, summarizes the 1624 inventory of the Delft silversmith Thomas Cruse, who owned a number of works by Tetrode, including "an alabaster *Christ,* a stone *St Eligius, Hercules, Leda,* a *Satyr,* an *Ox,* a *Tiger,* a *Boy on a Tortoise* and *Twelve Roman Emperors.*"

13. Anna Jolly, "Netherlandish Sculptors in Sixteenth-Century Northern Germany and Their Patrons," *Simiolus* 27, no. 3 (1999): 131, and Nijstad, "Tetrode," 271, no. 13.

14. Nijstad, "Tetrode," 270–72, and Jolly, "Netherlandish Sculptors," 132–36.

15. Jolly, in "Netherlandish Sculptors," 134, notes that "Rütger von der Horst owned a large print collection and lent reproductions to the artists working on chimney-pieces in his castle," but the quality of

the chimneypiece suggests to Jolly that Tetrode may have been directly involved.

16. Ibid., 132.

17. Carel van Mander, *The Lives of the Illustrious Netherlandish and German Painters, from the First Edition of the Schilder-boeck (1603–1604): Preceded by the Lineage, Circumstances and Place of Birth, Life and Works of Karel van Mander, Painter and Poet and Likewise His Death and Burial, from the Second Edition of the Schilder-boeck (1616–1618),* ed. Hessel Miedema (Doornspijk: Davaco Publishers, 1994), 1:178. Subsequent citations to van Mander's *Lives* are to this edition.

18. Jetty Van Der Sterre, "Weerdt [Weert], Adriaen de," in *The Grove Dictionary of Art* (London: Macmillan, 1996), 33:28–29; and Veldman, "Keulen als toevluchtsoord," 37–40.

19. Veldman, "Keulen als toevluchtsoord," 39.

20. Ibid., 40.

21. See, for example, Heinrich J. Schmidt, "Wechselwirkungen in der bildenden Kunst zwischen dem Niederrhein und den Niederlanden," *Niederrheinisches Jahrbuch* 8 (1965): 89–95. For examples of cultural and artistic exchange between the Low Countries and the Lower Rhine, see Stephen H. Goddard, *The Master of Frankfurt and His Shop* (Brussels: Paleis der Academiën, 1984), 38.

22. E. K. J. Reznicek, "Karel van Mander I," in *The Grove Dictionary of Art* (London: Macmillan, 1996), 20:244–48.

23. Walter S. Melion, "Karel van Mander's 'Life of Goltzius': Defining the Paradigm of Protean Virtuosity in Haarlem around 1600," *Studies in the History of Art* 27 (1989): 113–33.

24. For the drawings after antique sculpture see E. K. J. Reznicek, *Die Zeichnungen von Hendrick Goltzius* (Utrecht: Haentjens Dekker & Gumbert, 1961), 237–53.

25. Radcliffe, "Schardt, Tetrode, and Some Possible Sculptural Sources."

26. Nijstadt, in "Tetrode," 272n. 17, asks if Tetrode might have done a second *Hercules* that corresponds more exactly to Goltzius's *Great Hercules.* For the cognomen "Great Hercules" in an inventory of the 1620s, see Beth L. Holman, "Goltzius' Great Hercules: Mythology, Art and Politics," *Nederlands Kunsthistorisch Jaarboek* 42–43 (1991–92): 397–412, nn. 3 and 20.

27. Radcliffe, "Schardt, Tetrode, and Some Possible Sculptural Sources," 102, and see n. 13.

28. For the *Hercules Pomarius,* see Laura Camins, *Renaissance & Baroque Bronzes from the Abbott Guggenheim Collection,* exh. cat. (San Francisco: The Fine Arts Museums of San Francisco, 1988), 114–16.

29. For the *Nude Warrior,* see E. J. B. D. van Binnebeke, "Een godheid zonder harnas. Over Van Tetrode, Goltzius en een bronzen Olympiër," *Bulletin van het Rijksmuseum* 41, no. 1 (1993): 16–19, who relates the figure to the Jupiter in de Weerdt's print. See also Johannes Auersperg, *A Bronze Statuette of a Nude Warrior by Willem Danielsz. van Tetrode* (London: Daniel Katz Ltd., 1996): 1–7.

The identification of the *Nude Warrior/Deity* with the figure of Saturn, as well as the sculpture's relation to several of Goltzius's compositions, was first proposed by Charles Hack in correspondence with the authors (January 30, 2001). For a detailed comparison of these works, see the essay by James Ganz in this catalogue.

30. Radcliffe, "Schardt, Tetrode, and Some Possible Sculptural Sources," 105. Goltzius's drawing of Mercury, however, is a mirror image of Tetrode's sculpture. See Reznicek, *Hendrick Goltzius,* no. 152. The team writing this catalogue had intimate access to Tetrode's *Hercules Pomarius, Nude Warrior/Deity, Hercules and Antaeus, Christ at the Column,* and the *ecorché* that seems to show a man taming a horse. It is possible that close inspection of other works by Tetrode will yield further insights into the relationship with Goltzius.

31. Jolly, "Netherlandish Sculptors," 133.

32. Radcliffe, "Schardt, Tetrode, and Some Possible Sculptural Sources," 105.

33. Pieter J. J. van Thiel, *Cornelis Cornelisz van Haarlem 1562–1638: A Monograph and Catalogue Raisonné*, trans. Diane L. Webb (Doornspijk: Davaco Publishers, 1999), 62.

34. Van Mander, *Lives*, 1:26. The "Ovid" that van Mander refers to are the illustrations to Ovid's *Metamorphoses* engraved after Goltzius's designs (see figs. 64, 65). See Van Thiel, *Cornelis Cornelisz van Haarlem*, 60.

35. See Van Thiel, *Cornelis Cornelisz van Haarlem*, 59–90, for academy.

36. Ibid., 64–65, based on van Mander, *Lives*, 1:329–30. See also Walter S. Melion, *Shaping the Netherlandish Canon: Karel van Mander's "Schilder-Boeck"* (Chicago and London: University of Chicago Press, 1991), 63.

37. Van Thiel, *Cornelis Cornelisz van Haarlem*, 67, 69.

38. Eckhard Leuschner, "Francesco Villamena's Apotheosis of Alessandro Farnese and engraved reproductions of contemporary sculpture around 1600," *Simiolus* 27, no. 3 (1999): 159, "According to [Gaspare Celio's] own statements (and Baglione's biography) early in his career he had frequently copied antique and modern works for Hendrick Goltzius, although only one of the latter's prints (an *Isaiah after Raphael* [of 1592]) clearly states that he supplied the drawing."

39. Van Thiel, *Cornelis Cornelisz van Haarlem*, appendix 2, 253–74.

40. Ibid., p. 77, discusses Cornelis's source in Tetrode's *Hercules* and Michelangelo's *Bather* for the figures seen from the back in his painting *The Fall of Lucifer*: "he may have used the buttocks of this Hercules statue—determined as always to choose the most beautiful from the beautiful." On page 79 he discusses the importance of Tetrode's *Hercules Pomarius* for Cornelis's Ulysses seen from the back in his painting *Ulysses and Irus* (location unknown).

41. Ger Luijten and A. W. F. M. Meij, *From Pisanello to Cézanne: Master Drawings from the Museum Boymans-van Beuningen, Rotterdam*, exh. cat. (Cambridge: Cambridge University Press, 1990), 75. See also Ger Luijten et al., eds., *Dawn of the Golden Age: Northern Netherlandish Art 1580–1620*, exh. cat. (Amsterdam: Rijksmuseum, 1993), 344–45, no. 12. Caraglio's

importance for Goltzius was underscored by David Acton, "The Northern Masters in Goltzius's Meisterstiche," *Bulletin, Museums of Art and Archaeology, University of Michigan* 4 (1981): 40–53. See also Nancy Bialler, *Chiaroscuro Woodcuts: Hendrick Goltzius (1558–1617) and His Time*, exh. cat. (Amsterdam: Rijksmuseum, 1992), 103–4.

42. Luijten, *Dawn of the Golden Age*, 344–45.

43. Phyllis Pray Bober and Ruth Rubinstein, *Renaissance Artists & Antique Sculpture: A Handbook of Sources* (Oxford: Oxford University Press, 1986), 166–67.

44. Van Thiel, *Cornelis Cornelisz van Haarlem*, 77.

45. Walter L. Strauss, *Hendrick Goltzius 1558–1617: The Complete Engravings and Woodcuts* (New York: Abaris Books, 1977), 2:256, discussing Goltzius's *Apollo* of 1588, notes that Goltzius's "emphasis on the musculature derives form Netherlandish artists, like Maertin van Heemskerck, who had been inspired in this regard by Michelangelo."

46. Van Thiel, *Cornelis Cornelisz. van Haarlem*, 79.

47. Dorothy Limouze, "Engraving as Imitation: Goltzius and His Contemporaries," *Nederlands Kunsthistorisch Jaarboek* 42–43 (1991–92): 440–41.

48. Walter S. Melion, "Theory & Practice: Reproductive Engravings in the Sixteenth-Century Netherlands," in Timothy Riggs and Larry Silver, *Graven Images: The Rise of Professional Printmakers in Antwerp and Haarlem 1540–1640*, exh. cat. (Evanston: Mary and Leigh Block Gallery, Northwestern University, 1993), 48–51.

49. Van Mander, *Lives*, 1:394.

50. Melion, "Theory & Practice," 56.

51. Martin Kemp, "Coming into Line: Graphic Demonstrations of Skill in Renaissance and Baroque Engravings," in *Sight & Insight. Essays on Art and Culture in Honour of E. H. Gombrich at 85*, ed. John Onians (London: Phaidon Press Ltd., 1994), 233.

52. Walter S. Melion, "Hendrick Goltzius's Project of Reproductive Engraving," *Art History* 13, no. 4 (1990): 458.

53. See Melion, "Hendrick Goltzius's Project of Reproductive

Engraving," p. 460, where the significance of Cort for Goltzius is also examined.

54. Lee Hendrix, "Conquering Illusion: Bartholomeus Spranger's Influence in *Venus and Mars Surprised by Vulcan* by Hendrick Goltzius," in *Hendrick Goltzius and the Classical Tradition,* ed. Glenn Harcourt (Los Angeles: Fisher Art Gallery, University of Southern California, 1992), 66.

55. Walter S. Melion, "Piety and Pictorial Manner in Hendrick Goltzius's Early Life of the Virgin," in *Hendrick Goltzius and the Classical Tradition,* ed. Glenn Harcourt (Los Angeles: Fisher Art Gallery, University of Southern California, 1992), 44–51.

56. Frederick den Broeder, *Hendrik Goltzius & the Printmakers of Haarlem,* exh. cat. (Storrs: University of Connecticut Museum of Art, 1972), from the preface by Wolfgang Stechow, p. 9.

57. Luijten, *Dawn of the Golden Age,* 363. Also see Melion, "Karel van Mander's 'Life of Goltzius,'" 114: "Van Mander [in his Life of Goltzius] establishes Goltzius' title to surpassing teyckenconst and inventie by developing a metaphor—coined earlier by the humanist Schoneus in a dedication quatrain—that praises Goltzius' skill as a reproductive engraver: 'All these things I have related, prove Goltzius to be a rare Proteus or Vertumnus of art, capable of refashioning himself in the form of all the species of rendering.'"

58. Melion, "Theory & Practice," 62.

59. Elizabeth Nesbitt, "An Artist Picturing Art: Goltzius's *Portrait of the Painter Hans Bol and Pygmalion and Galatea,"* in *Hendrick Goltzius and the Classical Tradition,* ed. Glenn Harcourt (Los Angeles: Fisher Art Gallery, University of Southern California, 1992), 52–55, suggests that one of the copies of Praxiteles' *Cnidian Aphrodite* was Goltzius's source, although there is also a close resemblance to the Belvedere *Venus Felix and Amor* that we know Goltzius studied. For both statue types, see Bober and Rubinstein, *Renaissance Artists & Antique Scultpure,* 61–62. Goltzius's drawing after *Venus Felix and Amor* is in the Teylers Museum, Haarlem.

60. *The American Heritage Dictionary of the English Language,* 3rd edition (Boston and New York: Houghton Mifflin Company, 1992); Claire Farago, "Paragone," in *The Grove Dictionary of Art* (London: Macmillan, 1996), 24:90–91.

61. Erwin Panofsky, *Galileo as a Critic of the Arts* (The Hague: Martinus Nijhoff, 1954).

62. Peter Hecht, "The Paragone debate: Ten Illustrations and a Comment," *Simiolus* 14, no. 2 (1984): 125n. 3.

63. See Hessel Miedema, ed., *Carel van Mander. Den grondt der edel vry schilder-const* (Utrecht: Haentjens Dekker & Gumbert, 1973), commentary vol., 332, 333, 507, and 545.

64. Panofsky, *Galileo as a Critic of the Arts,* 9.

65. Leuschner, "Francesco Villamena's Apotheosis," 167.

66. Frits Scholten, *Adriaen de Vries 1556–1626,* exh. cat. (Amsterdam: Rijksmuseum, 1998), 13, and 246 and 260 for a possible relationship between de Vries's bronze *Hercules Pomarius* and that of Tetrode.

67. Jan Piet Filedt Kok, "Jan Harmensz. Muller as Printmaker I," *Print Quarterly* 11, no. 3 (September 1994): 236–40.

68. Luijten, *Dawn of the Golden Age,* 501, and Limouze, "Engraving as Imitation," 442–44. See also Limouze's analysis (pp. 445–48) of Goltzius's and Saenredam's engravings after Goltzius's drawings of Polidoro da Caravaggio's facade paintings in Rome as likely emanating from "the *paragone* between engraving and sculpture."

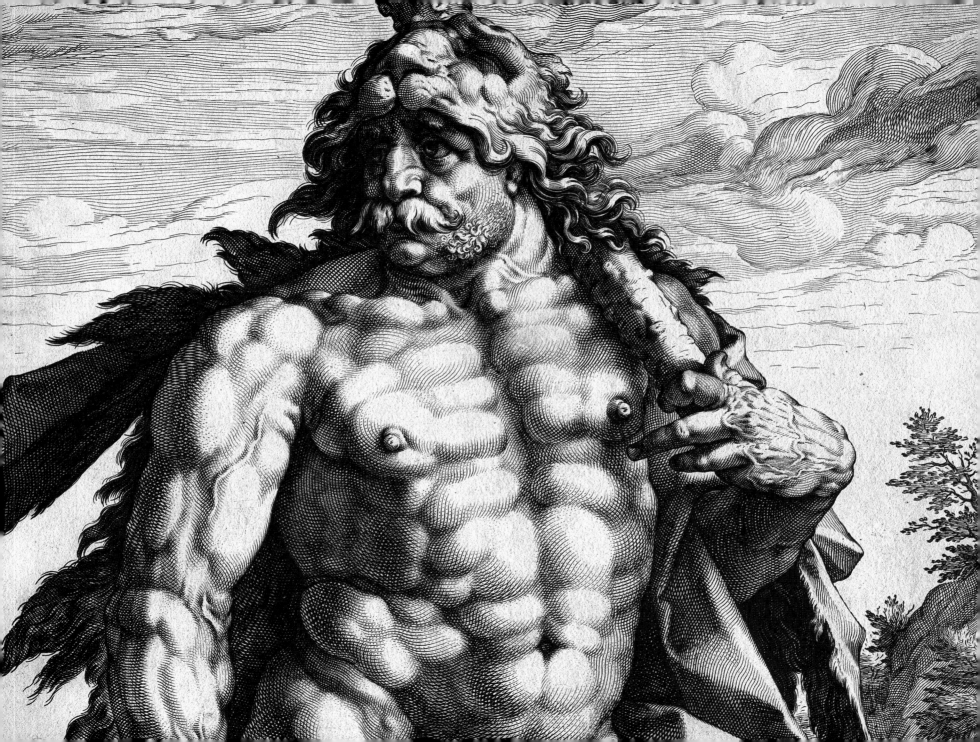

BODY DOUBLES: THE MUSCLEMEN *of* TETRODE *and* GOLTZIUS

JAMES A. GANZ

The theory that Hendrick Goltzius's celebrated musclemen were influenced by the less-well-known bronzes of the Delft sculptor Willem Danielsz. van Tetrode—first proposed by Jaap Leeuwenberg and Willy Halsema-Kubes (1973) and later elaborated by Anthony Radcliffe (1984)—has not received universal acceptance.[1] In this catalogue, Stephen Goddard summarizes the state of the literature and the historical background to this problem. In light of the lack of documentary evidence that Goltzius was ever in possession of Tetrode's statuettes, the principal method we have to refute or corroborate this hypothesis is close visual examination, an approach that has been hampered until now by the lack of availability of Tetrode's works. With this exhibition, in which Tetrode's bronzes are juxtaposed with engraved works by Goltzius, we were able to make several detailed comparisons between the two artists' figures.[2] The purpose of this essay is to summarize our findings.

Detail of Goltzius's
Great Hercules (fig. 7)

The prints under consideration date from the late 1580s, a period during which Goltzius and his fellow members of the so-called Haarlem Academy were intensely interested in representing the male nude. Their preoccupation is reflected in Goltzius's reproductive engravings after Bartholomeus Spranger (fig. 29) and Cornelis Cornelisz. van Haarlem (figs. 27, 28), as well as in his original compositions. It is within this latter group of prints, including the cycle of *The Roman Heroes* (1586), *The Massacre of the Innocents* (c. 1587–89), Ovid's *Metamorphoses* (1589), and *The Great Hercules* (1589), that we sought details of anatomy, physiognomy, and pose derived from Tetrode, with the caveat that Goltzius thoroughly processed his source material according to the academic principles of his day.[3] Taking into account his method of selection, alteration, improvement, and synthesis, we had to look beyond immediately recognizable, one-to-one correspondences in confirming visual sources in the bronzes of Tetrode.

THE HERCULES POMARIUS

The comparison of Tetrode's *Hercules Pomarius* (c. 1547–65; fig. 4) and Goltzius's *Great Hercules* (1589; fig. 7) has been central to previous discussions of Tetrode's influence on Goltzius, yet the relationship between these two works is hardly straightforward. In order to begin this analysis with unambiguous evidence of the *Pomarius* in Goltzius's graphic oeuvre we need to look elsewhere. One of the most persuasive indications that he had access to the bronze statuette is found in his unfinished engraving *The Massacre of the Innocents* (fig. 41), variously dated as early as 1584 and as late

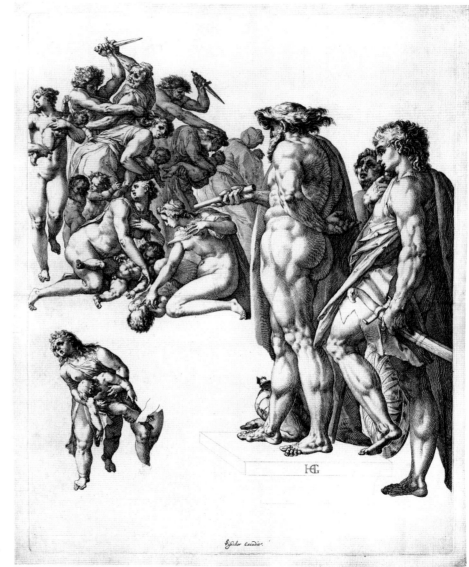

FIG. 41. Hendrick Goltzius, *The Massacre of the Innocents,* c. 1587–89. Engraving, 19 3/16 x 14 5/8 inches (48.7 x 37.2 cm). Collection of the Hearn Family Trust

as 1600, but most likely started during or shortly before 1587.[4] The unusually large plate represents the right half of a scene in which nude and semi-nude men, women, and children act out the horrific story recounted in the second chapter of Matthew.

While two of the subsidiary figures have been related to a drawing by Anthonie Blocklandt (1532–1583) in the Art Institute of Chicago,[5] it is the imposing body of King Herod the Great that is of primary interest. The profile view renders Herod effectively nude, with a mantle hanging from his right shoulder, revealing brawny musculature similar to that of the *Pomarius*. Herod's torso, buttocks and upper thigh (fig. 42) bear a striking resemblance to the left side of the bronze (fig. 43), and his left arm held behind his back, derived from the *Pomarius*'s gesture of hiding the apples of the Hesperides, serves no logical function here. The configuration of Herod's legs, with the right foot forward (fig. 44), corresponds to the *Pomarius*'s stance when the bronze is viewed from the opposite side and the image is reversed (fig. 45). Other than adjusting the angle of Herod's left foot, Goltzius faithfully transcribed the *Pomarius*'s muscular legs, which also seem to be reflected in the limbs of the young soldier stepping from behind. Indeed, from the angle shown in figure 45, the negative space between Herod's left calf and the left calf of the soldier is nearly identical to the space between the legs of the sculpture. Finally, it is tempting to identify the outlines of a step upon which Herod stands with what may have been an original pedestal for the *Pomarius*.[6]

FIG. 42. Detail of Goltzius's *Massacre of the Innocents* (fig. 41)

FIG. 43. Detail of Tetrode's *Hercules Pomarius* (fig. 4)

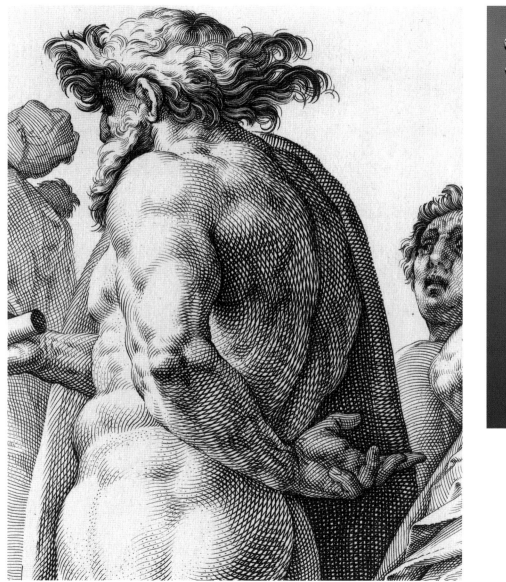

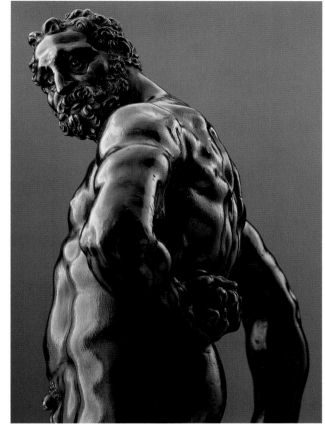

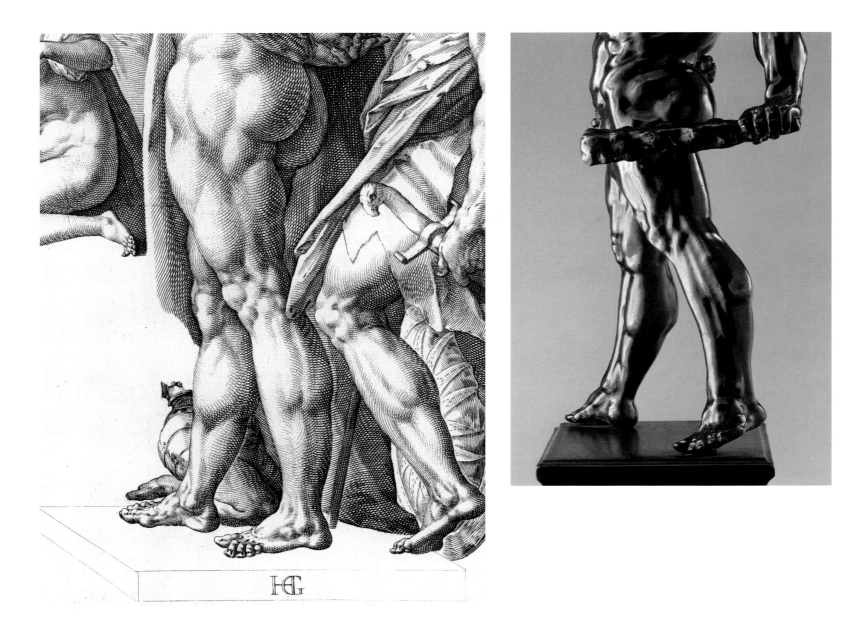

Armed with this strong visual confirmation that Goltzius had been exposed to Tetrode's *Hercules Pomarius*, subsequent comparisons can be made without the burden of proving the sculpture's presence, and instead Goltzius's prints can be considered in light of his method of transforming his sources. In taking on the subject of the standing nude Hercules, it is clear that Goltzius intended to surpass the exaggerated anatomy present in Tetrode's sculpture. His *Great Hercules* is bigger and stronger, characterized by an excessively muscle-bound, even freakish physique (fig. 7). His bulbous musculature presents the most extreme example of what E. K. J. Reznicek characterized as the artist's *Knollenstil* ("knobby or lumpy style").[7] The emphatic separation and protrusion of the various muscle groups heightens the virility of the figure at the expense of anatomical correctness. Even in portraying Hercules' powerful hands, Goltzius emphasized the bulging network of veins carrying lifeblood through his vital body, a detail not found in the *Pomarius* but related to a drawing of 1588 previously thought to represent Goltzius's own hand.[8]

Tetrode's *Hercules Pomarius* similarly flexes his muscles and shares the stocky proportions of *The Great Hercules*, particularly in his stubby feet. Although in his pectoral and abdominal regions, as well as in his legs, the bronze figure lacks the knobby bulges that are so distinctive to Goltzius's representation, in raking light his muscles appear powerfully exaggerated and more closely approximate *The Great Hercules*. Explicit association of this kind of mannered musculature with Tetrode is confirmed in two earlier prints in this exhibition that bear inscriptions that they reproduce Tetrode's

FIG. 44. Detail of Goltzius's *Massacre of the Innocents* (fig. 41)

FIG. 45. Detail of Tetrode's *Hercules Pomarius* (fig. 4) in reverse

sculptures: *Venus and Cupid with a Satyr,* published by Adriaen de Weerdt in 1574, and *Neptune's Kingdom* (fig. 46), engraved by Jacques de Gheyn II (1565–1629) and published by Goltzius in 1587.

The pose of *The Great Hercules* is also evocative of Tetrode's bronze.[9] The open-legged stance of the engraved figure, echoed in the representation of Hercules wrestling Antaeus in the background, is clearly informed by Tetrode's example. At the same time, his muscular arms perform different actions, his head turns in the opposite direction, and his balance of weight appears to be distributed on his right foot, as opposed to the sculpture, which leans on its left. The fact that the printed image reverses its original design may account for these and other similar transpositions to be noted below.

In their assertive muscularity, the chiaroscuro woodcuts *Mars in Half-Length* (fig. 47) and *Hercules and Cacus* (fig. 17) invite further comparison to the *Hercules Pomarius* (fig. 4). Nancy Bialler has observed that Mars's pose, with his wrist on his hip, was employed frequently by Goltzius in portrayals of pike-bearers and other military figures.[10] Some of these images were executed as early as 1583, at least three years prior to our first observance of Tetrode's influence in the works of Goltzius. Consequently, while Mars's thick arm is comparable to that of the *Pomarius,* his gesture, which strongly suggests a derivation from Tetrode, may only be coincidentally related to that of the *Hercules Pomarius.* In the case of *Hercules and Cacus,* Radcliffe observed the resemblance of Hercules' straddling pose to the *Pomarius,* although he noted an even closer correspondence with a Tetrode bronze

FIG. 46. Jacques de Gheyn II after Willem Danielsz. van Tetrode, *Neptune's Kingdom,* dated 1587. Engraving, diameter 9 15/16 inches (25.3 cm). Collection of the Hearn Family Trust

FIG. 47. Hendrick Goltzius,
Mars in Half-Length, c. 1588.
Chiaroscuro woodcut,
9 5/8 x 6 15/16 inches (24.5
x 17.6 cm). Collection of the
Hearn Family Trust

of *Hercules and Centaur* (fig. 18), now in a private collection, which was not available for examination.[11]

Like *The Farnese Hercules* engraved later by Goltzius (fig. 6), the *Hercules Pomarius* cuts as powerful a figure from the back as he does from the front. That Goltzius and his contemporaries were as enamored with the muscular male posterior as they were with the chest is demonstrated in several prints in this exhibition, three of which belong to the series of *The Roman Heroes* of 1586 (figs. 9, 11, and 12). It might be noted at this juncture that this cycle includes the earliest dated prints in Goltzius's oeuvre to reflect the idiom of Tetrode. Moreover, the influence throughout this series is as dramatic as it is pervasive. The closest figure to the *Pomarius* is *Marcus Valerius Corvus* (fig. 9), who poses with his legs spread apart and one arm behind his back. Here, as in the case of *The Great Hercules*, the arrangement of the arms of Goltzius's engraved figure mirrors that of the sculpture. This discussion of *The Roman Heroes* continues in the context of the two other bronzes included in this exhibition.

HERCULES AND ANTAEUS

The second bronze under consideration is *Hercules and Antaeus* known in a single cast in the Collection of the Hearn Family Trust (fig. 13). The bronze was only recently identified by Radcliffe as a work of Tetrode[12] and consequently has not been previously compared with Goltzius's prints.[13] The Hercules shares the facial type of the *Hercules Pomarius*, while the starfish-shaped head of hair on the Antaeus corresponds with that of the *Nude*

Warrior/Deity, discussed below. Although the pose of *Hercules and Antaeus* does not relate to the same subject in the background of Goltzius's *Great Hercules*, the group does bear comparison to three separate plates in the series of *The Roman Heroes*.

While in this case we cannot prove that Goltzius had access to this bronze, we can at least demonstrate how a single sculptural model might serve as the source for two poses as disparate as those shown in two plates from *The Roman Heroes*. *Caius Muscius Scaevola* holds his sword with his right arm out across his chest, while *Titus Manlius Torquatus* reaches around to grip the hilt of his sword, not yet removed from its scabbard. Photographs of the bronze taken from two angles show how it is possible, by varying the point of view, to discern both of these poses in the figure of Hercules breaking the back of Antaeus (figs. 48–51).

Moving around the bronze group, it is possible to make an interesting comparison between Hercules' back and that of the recumbent river god in the frontispiece to *The Roman Heroes* (figs. 52, 53). While this visual evidence seems compelling and the musculature appears to mimic Tetrode, a direct borrowing is by no means certain. This pose was in fact part of the Haarlem Academy's standard repertoire and may be traced originally to the ancient *Torso Belvedere*.[14] In the absence of additional corroboration, it seems judicious in this instance to leave open the question of a direct relationship between Tetrode's Hercules and Goltzius's river god. They may instead have shared a common ancestor.

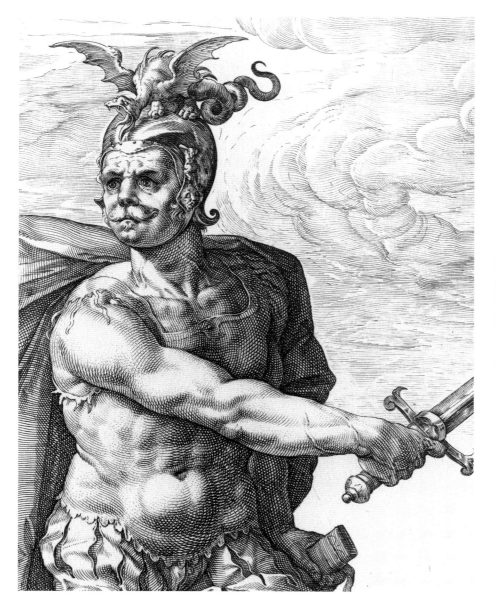

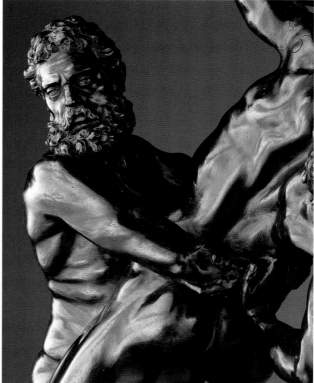

FIG. 48. Detail of Goltzius's
Caius Muscius Scaevola (fig. 24)

FIG. 49. Detail of Tetrode's
Hercules and Antaeus (fig. 13)

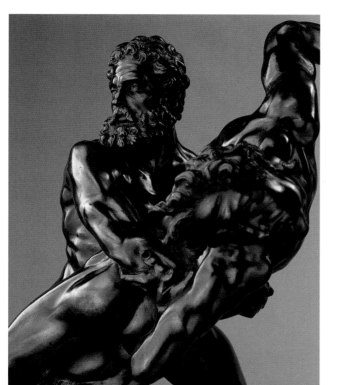

FIG. 50. Detail of Tetrode's
Hercules and Antaeus (fig. 13)

FIG. 51. Detail of Goltzius's
Titus Manlius Torquatus (fig. 25)

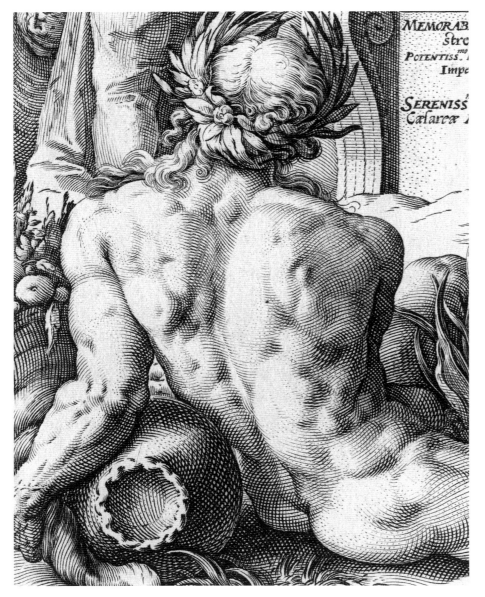

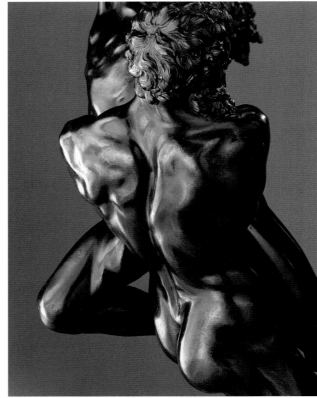

FIG. 52. Detail of Goltzius' frontispiece to *The Roman Heroes* (fig. 11)

FIG. 53. Detail of Tetrode's *Hercules and Antaeus* (fig. 13)

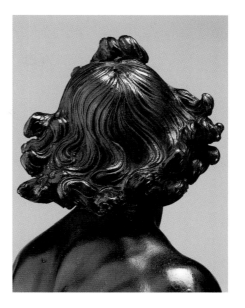

THE NUDE WARRIOR/DEITY

FIG. 54. Detail of Tetrode's
Nude Warrior/Deity (fig. 10)

The final bronze under consideration is a striding nude man that Radcliffe first attributed to Tetrode (fig. 10) and, interpreting his pose as combative, identified as a warrior.[15] Certain details in the cast belonging to the Hearn Family Trust suggest the loss of accessories that may have originally clarified his identity. A small hole and residual light-colored ring in the patina of the figure's hair (fig. 54) hint that he once wore headgear, and the butt-end of an object, possibly a weapon or scepter, remains in his right hand. Based on its small size, the aureole may reflect the presence of a small crown rather than an elaborate helmet of the type shown in Goltzius's *Roman Heroes*. If this theory is correct, it is plausible to conclude that the figure was meant to portray a deity.[16]

It is especially intriguing, then, to compare the bronze's posterior to Goltzius's *Pluto* (fig. 55), who does wear a crown. Moving around the sculpture and viewing it from several different angles, we find striking similarities of both anatomy and pose that provide convincing evidence in favor of Goltzius's use of this model. The outstretched left arm of the sculpture, when viewed from below and to the figure's left, matches the left arm of *Pluto* (figs. 56, 57), while the sculpture's right arm, when seen from an elevated perspective, appears to resolve itself into *Pluto's* foreshortened right arm (figs. 58, 59). The bronze's back, buttocks, and legs, when viewed in reverse, also closely correspond to Goltzius's figure (figs. 60–63). However, Pluto's trident does not match the fragmentary hilt held by the bronze.

In *The Giants Scaling the Heavens* (fig. 65), from the series of illustrations of Ovid's *Metamorphoses* designed by Goltzius and engraved by a member of his workshop, Saturn, too, wears a crown. The pose of his upper body is dependent on the *Nude Warrior/Deity,* particularly the left arm holding the scepter, the handle of which corresponds directly to the remnant held in the right hand of the sculpture (fig. 58). At the same time, the straddling pose of Saturn's legs is rather more reminiscent of the *Hercules Pomarius* (fig. 5). In *The Age of Fire* (fig. 64), the frontal figure of Mars gives the impression of Saturn's mirror image rotated 180 degrees and, again, suggests the possibility of an anatomical pastiche based on Tetrode's sculptures, with the torso derived from the *Nude Warrior/Deity* and the legs taken from the *Pomarius.*[17]

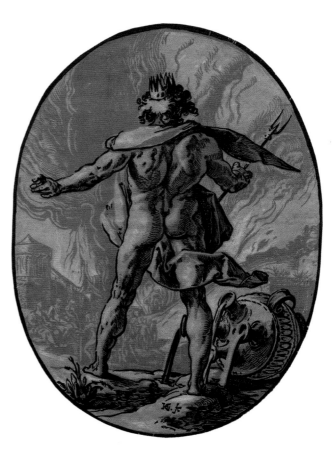

FIG. 55. Hendrick Goltzius, *Pluto,* c. 1588–90. Chiaroscuro woodcut, 13 11/16 x 9 13/16 inches (34.7 x 25 cm). Collection of the Hearn Family Trust

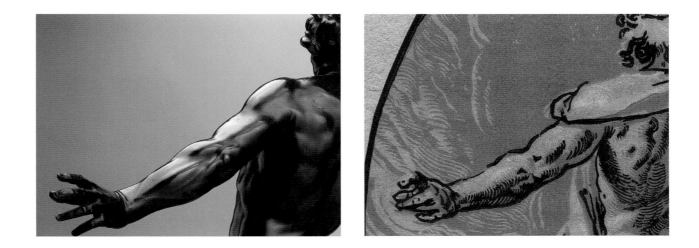

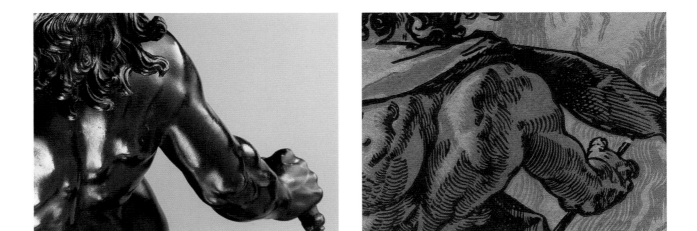

Fig. 56. Detail of Tetrode's
Nude Warrior/Deity (fig. 10)

Fig. 57. Detail of Goltzius's
Pluto (fig. 55)

Fig. 58. Detail of Tetrode's
Nude Warrior/Deity (fig. 10)

Fig. 59. Detail of Goltzius's
Pluto (fig. 55)

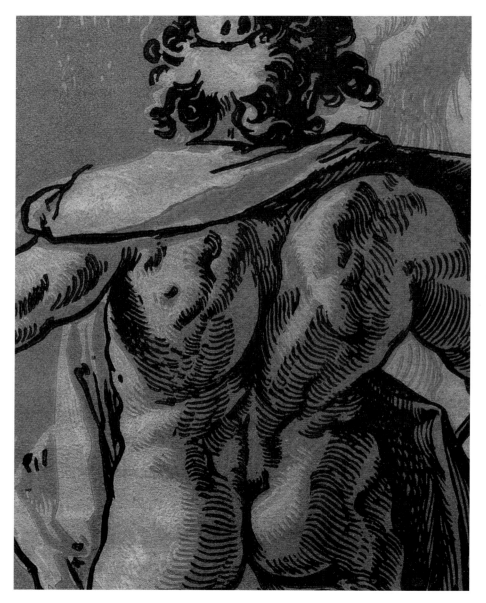

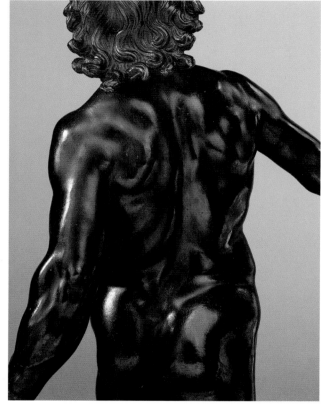

FIG. 60. Detail of Goltzius's
Pluto (fig. 55)

FIG. 61. Detail of Tetrode's
Nude Warrior/Deity (fig. 10)
in reverse

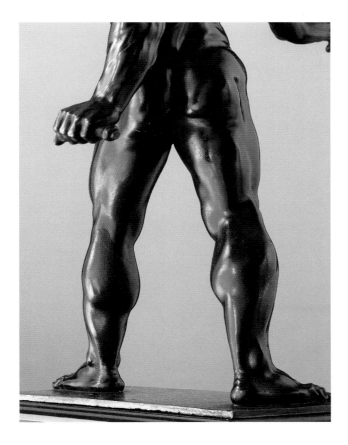

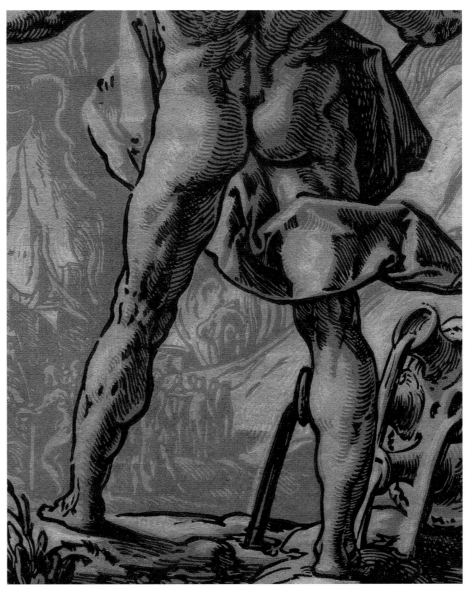

FIG. 62. Detail of Tetrode's
Nude Warrior/Deity (fig. 10)
in reverse

FIG. 63. Detail of Goltzius's
Pluto (fig. 55)

One of Radcliffe's most persuasive observations in his paper on Goltzius's sculptural sources is his comparison of the *Nude Warrior/Deity*'s pose with that of *Calphurnius* from *The Roman Heroes* (figs. 66, 67). The body type, stride, and arm gestures are conspicuously similar. If we look elsewhere in the same series, we can discern additional evidence of Goltzius's use of this bronze as a model. Seen from the opposite side and a slightly higher angle, the *Nude Warrior/Deity*'s legs mirror those of *Horatius Cocles* (figs. 68, 69). From a lower angle and in reverse, the chest and belly of Tetrode's bronze correspond to the torso of *Publius Horatius* (figs. 70, 71) and, pulling back and to the right, again in reverse, to the figure of *Apollo* dated 1588 (figs. 72, 73).

FIG. 64. Workshop of Hendrick Goltzius, *The Age of Fire,* from Ovid's *Metamorphoses,* c. 1589. Engraving, 6 13/16 x 9 15/16 inches (17.3 x 25.3 cm). Collection of the Hearn Family Trust

FIG. 65. Workshop of Hendrick Goltzius, *The Giants Scaling the Heavens,* from Ovid's *Metamorphoses,* c. 1589. Engraving, 6 15/16 x 10 inches (17.6 x 25.4 cm). Collection of the Hearn Family Trust

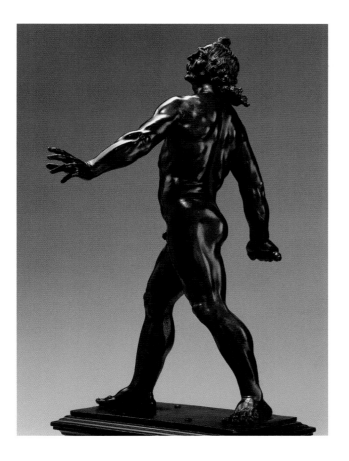

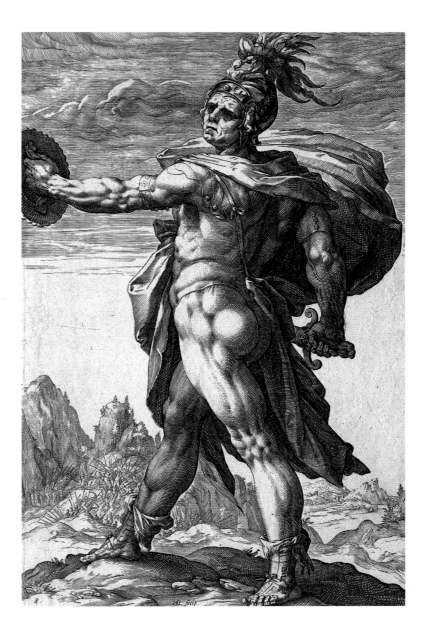

FIG. 66. Tetrode's *Nude Warrior/Deity* (fig. 10)

FIG. 67. Detail of Goltzius's *Calphurnius* (fig. 12)

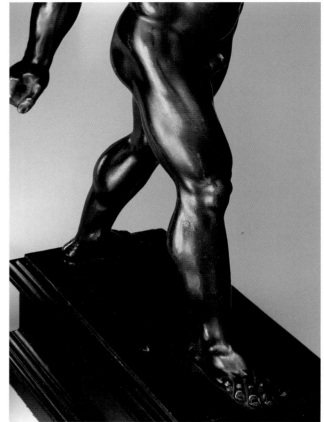

FIG. 68. Detail of Goltzius's
Horatius Cocles (fig. 23)

FIG. 69. Detail of Tetrode's
Nude Warrior/Deity (fig. 10)

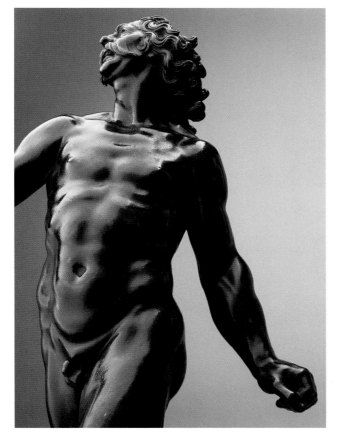

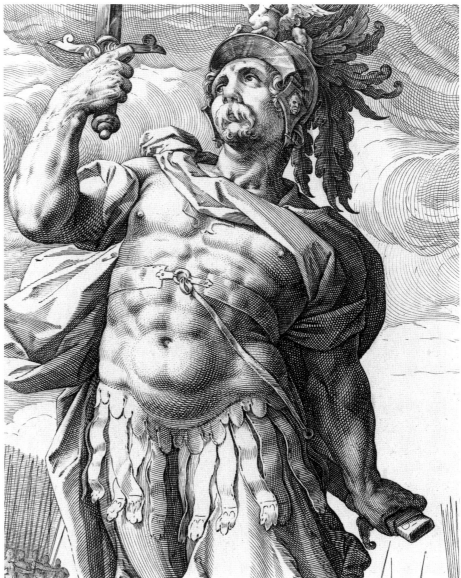

FIG. 70. Detail of Tetrode's
Nude Warrior/Deity (fig. 10)
in reverse

FIG. 71. Detail of Goltzius's
Publius Horatius (fig. 22)

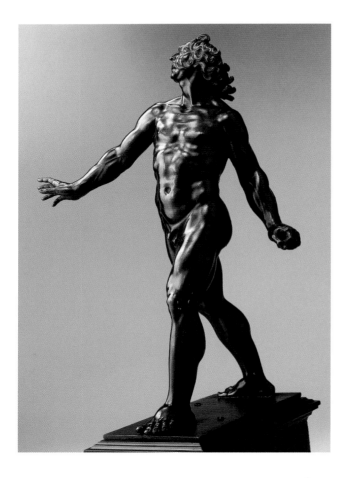

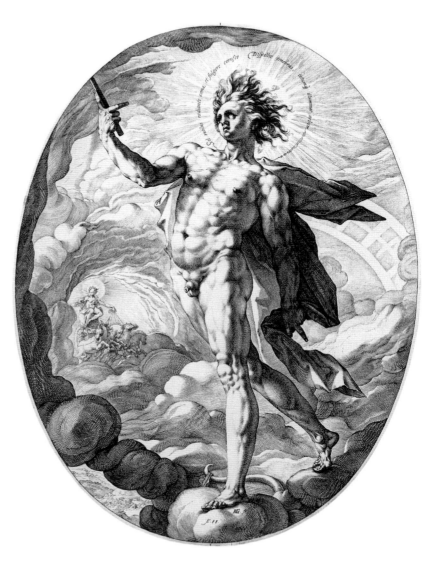

FIG. 73. Hendrick Goltzius,
Apollo, dated 1588. Engraving,
13 11/16 x 10 1/4 inches
(34.7 x 26 cm). Collection of
the Hearn Family Trust

FIG. 72. Tetrode's *Nude
Warrior/Deity* (fig. 10) in reverse

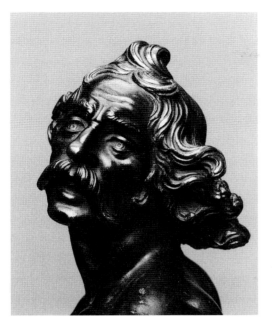

FIG. 74. Detail of Tetrode's
Nude Warrior/Deity (fig. 10)

Radcliffe also pointed out the recurrence of the *Nude Warrior/Deity's* facial type (fig. 74) in the prints of Goltzius of the mid- to late 1580s.[18] His bushy mustache crops up on *The Great Hercules* (fig. 7), both figures in *Hercules and Cacus* (fig. 17), *Mars in Half-Length* (fig. 47), and seven of the eight *Roman Heroes* (figs. 9, 22–25). Curiously, this otherwise ubiquitous feature is only lacking on *Calphurnius* (fig. 12), previously identified as bearing the most direct relationship to Tetrode's bronze. The *Nude Warrior/Deity's* swirling shock of hair is also a fixture of Goltzius's musclemen of this period, with the exception of the warriors, all of whom wear helmets.

Finally, I want to emphasize a fundamental point of similarity between Tetrode's *Nude Warrior/Deity* and Goltzius's *Roman Heroes* that seems to have escaped previous notice: namely, the relative scale of the figures. From the late 1570s through the mid-1580s, Goltzius gradually increased the size of his copper plates to accommodate his increasingly monumental figures. His earliest series of single figures, *The Five Senses* (c. 1578; Strauss 32–36), was engraved on plates approximately 14 by 9 cm. *The Seven Virtues* (1578–80; Strauss 67–73) measure approximately 20 by 10 cm each, and the miscellaneous single sheets of warriors, pike-bearers, and portraits of the early 1580s generally measure up to 21 to 25 cm. When Goltzius turned his attention to *The Roman Heroes,* he employed plates approximately 35 by 23 cm, and for the first figure in the series, *Publius Horatius,* 39 by 25 cm. The figures themselves approach the size of Tetrode's bronzes, varying in height from 30 to 35 cm, just 4 to 9 cm shorter than the *Nude Warrior/Deity.* The sculptural presence of Goltzius's *Roman Heroes* is unquestionably enhanced by their scale; they

stand up, both literally and figuratively, to the bronze statuette that appears to have inspired them.

Much of the visual evidence in this study supports the conclusion that allusions to the bronzes of Tetrode in the prints of Hendrick Goltzius were not merely coincidental. While their differences may be attributed to artistic license, it remains intriguing to see these monumental figures as kinsmen, rather than unrelated progeny of the same zeitgeist. As Goddard and many others have underscored, Goltzius was a master at assimilating various artistic influences. He was also adept at manipulating his three-dimensional models in space, combining various points of view, selectively recording and ultimately synthesizing anatomical details to invent new poses. Goltzius took full advantage of describing his models from multiple angles, transcending the simple pivoting or reversal of motifs that is characteristic of artists working from two-dimensional sources.[19]

1. For instance, Beth L. Holman explicitly rejected the theory in her paper "Goltzius' *Great Hercules*: Mythology, Art and Politics," in *Goltzius-Studies: Hendrick Goltzius (1558–1617),* ed. Reindert Falkenburg, Jan Piet Filedt Kok, and Huigen Leeflang (Zwolle: Waanders, 1993), 407n. 7. Tetrode was not mentioned by Larry Silver, who exclusively concentrated on the influence of Spranger in his essay "Imitation & Emulation: Goltzius as Evolutionary Reproductive Engraver," in *Graven Images: The Rise of Professional Printmakers in Antwerp and Haarlem, 1540–1640,* exh. cat. (Evanston: Mary and Leigh Block Gallery, Northwestern University, 1993), 71–99.

2. Our method of examination was to place each of the bronzes on a rotating platform and, with the aid of a digital camera connected to a computer, identify angles of view from which the sculptures most closely correspond to the figures in Goltzius's prints. The digital captures served as the models for the reproductions in this catalogue.

3. See Pieter J. J. van Thiel, *Cornelis Cornelisz van Haarlem 1562–1638: A Monograph and Catalogue Raisonné,* trans. Diane L. Webb (Doornspijk: Davaco Publishers, 1999), chap. 2, "The Artist's Triple Training."

4. Otto Hirschmann, *Verzeichnis des graphischen Werks von Hendrick Goltzius* (Leipzig: Klinkhardt & Biermann, 1919), 122, 125, dated the plate after 1600; E. K. J. Reznicek, *Die Zeichnungen von Hendrick Goltzius* (Utrecht: Haentjens, Dekker & Gumbert, 1961), 1:68, 145, dated it c. 1585; Walter L. Strauss, *Hendrick Goltzius 1558–1617: The Complete Engravings and Woodcuts* (New York: Abaris Books, 1977), 1:340, dated it c. 1584.

5. Reznicek, *Die Zeichnungen von Hendrick Goltzius,* 1:145n. 22.

6. The wooden pedestal of the *Hercules Pomarius* in the Collection of the Hearn Family Trust is not original to the bronze.

7. Reznicek, *Die Zeichnungen von Hendrick Goltzius,* 1:71–72; Nancy Bialler, *Chiaroscuro Woodcuts: Hendrick Goltzius (1558–1617) and His Time,* exh. cat. (Amsterdam: Rijksmuseum, 1992), 81.

8. Reznicek, *Die Zeichnungen von Hendrick Goltzius,* 2:86; Van Thiel, *Cornelis Cornelisz van Haarlem,* 82.

9. Carmen Bambach, in "A Leonardo Drawing for the Metropolitan Museum of Art: Studies for a Statue of *Hercules,*" *Apollo* 153, no. 469 (March 2001): 16–23, has traced the "vigilant Hercules type" of Tetrode's *Pomarius* (and by extension, Goltzius's *Great Hercules*) to a sculpture project by Leonardo da Vinci reflected in a drawing in the collection of the Metropolitan Museum of Art, New York.

10. Bialler, *Chiaroscuro Woodcuts,* 95.

11. Anthony Radcliffe, "Schardt, Tetrode, and Some Possible Sculptural Sources for Goltzius," in *Netherlandish Mannerism: Papers Given at a Symposium in Nationalmuseum Stockholm, September 21–22, 1984,* ed. Görel Cavalli-Björkman (Stockholm: Nationalmuseum, 1985), 103–4, fig. 9, now in a private collection.

12. Johannes Auersperg, *Daniel Katz: European Sculpture, New York, May 8th to May 19th, 2000,* exh. cat. (New York: Daniel Katz Ltd., 2000), no. 20.

13. Radcliffe, "Schardt, Tetrode, and Some Possible Sculptural Sources," 100, 108, discusses another version of *Hercules and Antaeus* by Tetrode in the Victoria and Albert Museum, London.

14. Van Thiel, *Cornelis Cornelisz van Haarlem,* 76–77.

15. Radcliffe, "Schardt, Tetrode, and Some Possible Sculptural Sources," 104–5.

16. These observations were first conveyed to me by Charles Hack (January 30, 2001). The close correspondence between the hair, upper body, arm, and weapon of Saturn in *The Giants Scaling the Heavens* and that of the *Nude Warrior/Deity,* and the possibility that the bronze originally wore a crown has led Hack to speculate that the bronze was meant to portray Saturn.

17. Again, I thank Charles Hack for these observations.

18. Radcliffe, "Schardt, Tetrode, and Some Possible Sculptural Sources," 103.

19. See Laurie Fusco, "The Use of Sculptural Models by Painters in Fifteenth-Century Italy," *The Art Bulletin* 64, no. 2 (June 1982): 175–94.

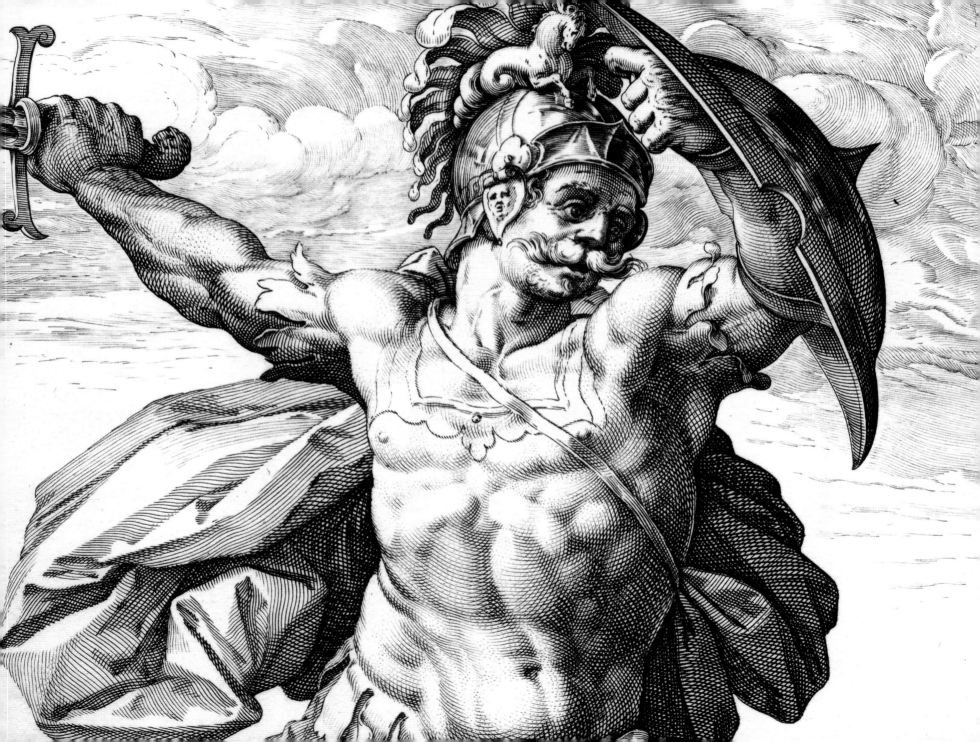

All works are from the Collection of the Hearn Family Trust, unless otherwise noted. Dimensions for engravings refer to plate dimensions. The following abbreviations have been used for citing cross-references in the checklist:

B Bartsch, Adam von. *Le peintre-graveur*. 21 vols. Vienna, 1803–21.

H Hollstein, F. W. H. *Dutch and Flemish Etchings, Engravings, and Woodcuts, ca. 1450–1700*. Amsterdam: M. Hertzberger, 1949–.

IB Bartsch, Adam von. *The Illustrated Bartsch*. Vol. 3, *Netherlandish Artists: Hendrick Goltzius*, and Vol. 4, *Netherlandish Artists: Matham, Saenredam, Muller*. Ed. Walter L. Strauss. New York: Abaris Books, 1980–82.

NB Bialler, Nancy. *Chiaroscuro Woodcuts: Hendrick Goltzius (1558–1617) and His Time*. Exh. cat. Amsterdam: Rijksmuseum, 1992.

NH *The New Hollstein: Dutch & Flemish Etchings, Engravings, and Woodcuts, 1450–1700*. Roosendaal, Netherlands: Koninklijke van Poll in cooperation with the Rijksprentenkabinet, Rijksmuseum Amsterdam, 1993–.

S Strauss, Walter L. *Hendrick Goltzius, 1558–1617: The Complete Engravings and Woodcuts*. New York: Abaris Books, 1977.

Detail of Goltzius's
Horatius Cocles (fig. 23)

1. Willem Danielsz. van Tetrode
Dutch, c. 1525–1580
Hercules Pomarius, c. 1547–65
Bronze
Height 15 1/2 inches (39.4 cm)
Figs. 4, 5, 43, 45

2. Willem Danielsz. van Tetrode
Nude Warrior/Deity, 1565–75
Bronze
Height 15 3/4 inches (40 cm)
Figs. 10, 54, 56, 58, 61, 62, 66, 69, 70, 72, 74

3. Willem Danielsz. van Tetrode
Hercules and Antaeus, c. 1570
Bronze
Height 20 1/2 inches (52 cm)
Figs. 13, 14, 49, 50, 53

4. Hendrick Goltzius
Dutch, 1558–1617
Mars and Venus Surprised by Vulcan, dated 1585
Engraving (first state of three)
16 1/2 x 12 3/16 inches (42 x 31 cm)
S216; B139; H137
Fig. 30

5. Hendrick Goltzius
Frontispiece to *The Roman Heroes,* dated 1586
Engraving (unrecorded state between the first
and second states of three)
14 1/2 x 9 1/4 inches (36.8 x 23.5 cm) trimmed
S230; B94; H161
Figs. 11, 52

6. Hendrick Goltzius
Publius Horatius, from *The Roman Heroes,*
dated 1586
Engraving (second state of two)
14 5/8 x 9 1/4 inches (37.1 x 23.5 cm)
S231; B96; H162
Figs. 22, 71

7. Hendrick Goltzius
Horatius Cocles, from *The Roman Heroes,* c. 1586
Engraving (second state of two)
14 5/8 x 9 5/16 inches (37.1 x 23.6 cm)
S232; B97; H163
Figs. 23, 68

8. Hendrick Goltzius
Caius Muscius Scaevola, from *The Roman Heroes,*
c. 1586
Engraving (second state of two)
14 5/8 x 9 1/4 inches (37.1 x 23.5 cm)
S233; B98; H164
Figs. 24, 48

9. Hendrick Goltzius
Marcus Curtius, from *The Roman Heroes,* c. 1586
Engraving (second state of two)
14 5/8 x 9 5/16 inches (37.1 x 23.7 cm)
S234; B99; H165

10. Hendrick Goltzius
Titus Manlius Torquatus, from *The Roman Heroes,*
c. 1586
Engraving (second state of two)
14 5/8 x 9 1/4 inches (37.1 x 23.5 cm)
S235; B100; H166
Figs. 25, 51

11. Hendrick Goltzius
Titus Manlius on Horseback, from *The Roman
Heroes,* c. 1586
Engraving (second state of two)
14 5/8 x 9 3/16 inches (37.1 x 23.4 cm)
S237; B102; H168

12. Hendrick Goltzius
Calphurnius, from *The Roman Heroes,* c. 1586
Engraving (second state of two)
14 5/8 x 9 1/4 inches (37.1 x 23.5 cm)
S238; B103; H169
Figs. 12, 67

13. Hendrick Goltzius
Fame and History, from *The Roman Heroes,*
dated 1586
Engraving (first state of three)
14 5/8 x 9 1/8 inches (37.1 x 23.2 cm) trimmed
S239; B95; H170

14. Hendrick Goltzius
Marcus Valerius Corvus, from *The Roman Heroes,*
c. 1586
Engraving (only state)
14 5/8 x 9 1/4 inches (37.1 x 23.5 cm)
S236; B101; H167
Fig. 9

15. Hendrick Goltzius
After Bartholomeus Spranger (Flemish,
1546–1611)
The Wedding of Cupid and Psyche, dated 1587
Engraving (first state of four, printed on
three sheets)
16 13/16 x 33 7/16 inches (42.7 x 85 cm)
S255; B277; H322
Fig. 29

16. Hendrick Goltzius
The Massacre of the Innocents, c. 1587–89
Engraving (second state of three)
19 3/16 x 14 5/8 inches (48.7 x 37.2 cm)
S206; B23; H17
Figs. 41, 42, 44

17. Hendrick Goltzius
Apollo, dated 1588
Engraving (only state)
13 11/16 x 10 1/4 inches (34.7 x 26 cm)
S263; B141; H131
Fig. 73

18. Hendrick Goltzius
After Cornelis Cornelisz. van Haarlem
(Dutch, 1562–1638)
Tantalus, from *The Four Disgracers,* dated 1588
Engraving (first state of three)
Diameter 13 1/16 inches (33.2 cm)
S257; B258; H306

19. Hendrick Goltzius
After Cornelis Cornelisz. van Haarlem
Icarus, from *The Four Disgracers,* c. 1588
Engraving (first state of three)
Diameter 13 1/16 in (33.1 cm)
S258; B259; H307
Bowdoin College Museum of Art, Brunswick,
Maine. Gift of David P. Becker, Class of 1970

20. Hendrick Goltzius
After Cornelis Cornelisz. van Haarlem
Phaeton, from *The Four Disgracers,* c. 1588
Engraving (first state of three)
Diameter 12 15/16 inches (32.9 cm)
S259; B260; H308
Fig. 27

21. Hendrick Goltzius
After Cornelis Cornelisz. van Haarlem
Ixion, from *The Four Disgracers,* c. 1588
Engraving (first state of three)
Diameter 13 1/16 inches (33.1 cm)
S260; B261; H309
Fig. 28

22. Hendrick Goltzius
After Cornelis Cornelisz. van Haarlem
The Dragon Devouring the Companions of Cadmus,
dated 1588
Engraving (first state of four)
9 13/16 x 12 1/2 inches (25 x 31.8 cm)
S261; B262; H310
Fig. 20

23. Hendrick Goltzius
Hercules and Cacus, dated 1588
Chiaroscuro woodcut
16 x 13 1/16 inches (40.6 x 33.1 cm)
S403; B231; H373; NB25Ie
Fig. 17

24. Hendrick Goltzius
Mars in Half-Length, c. 1588
Chiaroscuro woodcut
9 5/8 x 6 15/16 inches (24.5 x 17.6 cm)
S406; B230; H366; NB24II
Fig. 47

25. Hendrick Goltzius
Pluto, c. 1588–90
Chiaroscuro woodcut
13 11/16 x 9 13/16 inches (34.7 x 25 cm)
S423; B233; H369; NB29c
Figs. 55, 57, 59, 60, 63,

26. Hendrick Goltzius
The Great Hercules, dated 1589
Engraving (first state of two)
21 13/16 x 15 3/4 inches (55.4 x 40 cm) trimmed
S283; B142; H143
Fig. 7

27. Hendrick Goltzius
The Farnese Hercules, c. 1592
Engraving (second state of two)
16 7/16 x 11 13/16 inches (41.8 x 30 cm)
S312; B143; H145
Fig. 6

28. Hendrick Goltzius
Hercules and Telephos, c. 1592
Engraving (second state of two)
16 3/8 x 11 7/8 inches (41.7 x 30.1 cm)
S313; B144; H146
Fig. 36

29. Hendrick Goltzius
The Apollo Belvedere, c. 1592
Engraving (second state of two)
16 5/16 x 11 13/16 inches (41.5 x 30 cm)
S314; B145; H147
Fig. 34

30. Hendrick Goltzius
Pygmalion and Galatea, dated 1593
Engraving (second state of four)
12 15/16 x 8 9/16 inches (32.8 x 21.7 cm)
S315; B138; H158
Fig. 35

31. Workshop of Hendrick Goltzius
The Giants Scaling the Heavens, from Ovid's
Metamorphoses, c. 1589
Engraving
6 15/16 x 10 inches (17.6 x 25.4 cm).
S (p. 775); IB302.037
Fig. 65

32. Workshop of Hendrick Goltzius
The Age of Fire, from Ovid's *Metamorphoses,*
c. 1589
Engraving
6 13/16 x 9 15/16 inches (17.3 x 25.3 cm)
S (p. 776); IB302.032
Fig. 64

33. Attributed to Adriaen de Weerdt
Flemish, c. 1510–c. 1590
After Willem Danielsz. van Tetrode
Venus and Cupid with a Satyr, dated 1574
Engraving (first state of two)
14 15/16 x 20 3/16 inches (37.9 x 51.3 cm)
H9

34. Jacques de Gheyn II
Dutch, 1565–1629
After Willem Danielsz. van Tetrode
Neptune's Kingdom, dated 1587
Engraving (first state of two)
Diameter 9 15/16 inches (25.3 cm)
NH141
Fig. 46

35. Jan Muller
Dutch, 1571–1628
After Adriaen de Vries (Dutch, 1556–1626)
Mercury Abducting Psyche (Mercury Seen in Profile),
dated 1593
Engraving (second state of four)
21 7/8 x 10 1/16 inches (55.6 x 25.6 cm)
IB82; NH82
Fig. 40A

36. Jan Muller
After Adriaen de Vries
Mercury Abducting Psyche (Mercury Seen in Full Face),
dated 1593
Engraving (second state of four)
21 7/8 x 10 1/16 inches (55.6 x 25.6 cm)
IB83; NH83
Fig. 40B

37. Jan Muller
After Adriaen de Vries
*Mercury Abducting Psyche (Mercury Seen from the
Rear),* dated 1593
Engraving (second state of four)
21 7/8 x 10 1/16 inches (55.6 x 25.6 cm)
IB84; NH84
Fig. 40C

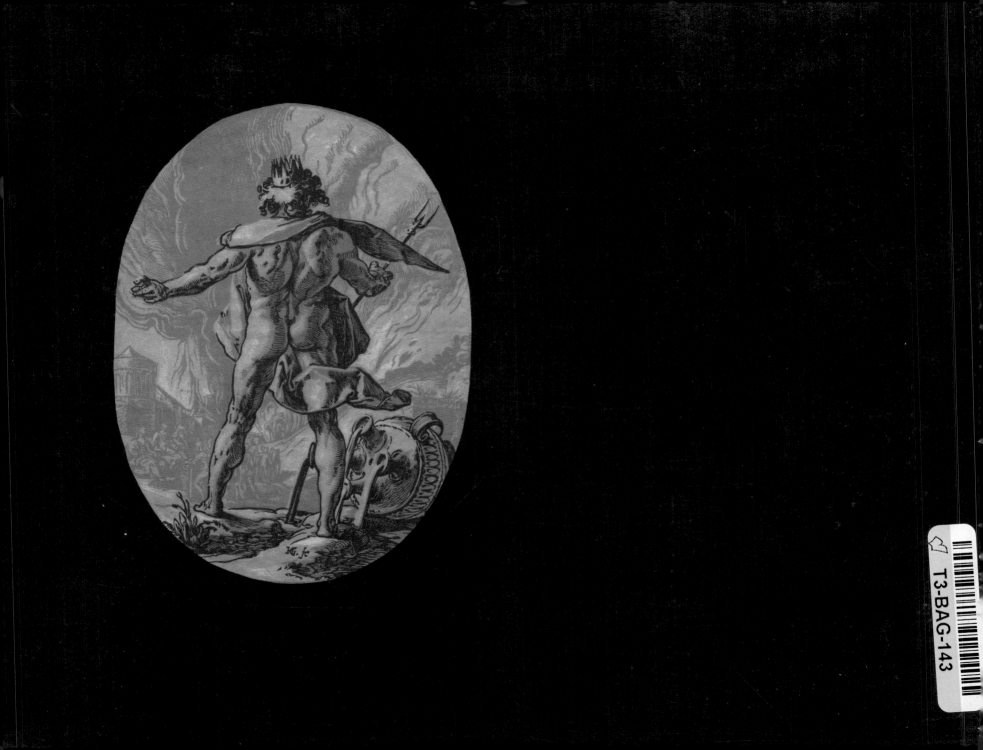